"This book illustrates a truth we cannot ignore. Class conflict is at the heart of our society, the inevitable consequence of this economic system. This should be the first principle of our politics. Paul Sng also shows another eternal truth: in the end, people always fight back. Our task is to ensure that their resistance is not in vain."

D1211024

First published in Great Britain in 2018 by

Policy Press
University of Bristol, 1-9 Old Park Hill, Bristol, BS2 8BB, UK
t: +44 (0)117 954 5940 | pp-info@bristol.ac.uk | www.policypress.co.uk

North America office:
Policy Press
c/o The University of Chicago Press, 1427 East 60th Street, Chicago, IL 60637, USA
t: +1 773 702 7700 | f: +1 773-702-9756 | sales@press.uchicago.edu | www.press.uchicago.edu

Cover and text design by blu inc, Bristol
Printed and bound in Great Britain by Cambrian Printers, Aberystwyth
Policy Press uses environmentally responsible print partners

Editor and Creative Director: Paul Sng
Curator and Project Manager: Laura Dicken
Assistant Editors: Kiran Acharya, Peter Cary, Melissa Rose
Interview transcriptions: Vicky Millington
Editorial Assistant: Dan Butler
Creative Consultants: Kiran Acharya, Chloe Juno

Cover photographer: Bobby Beasley

 invisiblebritain @invisiblebritain @velvetjoyltd

www.invisiblebritain.com

INVISIBLE BRITAIN
PORTRAITS OF HOPE AND RESILIENCE

"This is not just a collection of tender, beautiful photographs that give dignified people their rightful voice, but a record of austerity's stain on our country. The invisibility of the people in these stories is how the government has got away with the last eight years of destroying our communities, our social security system and our public services. We must amplify their voices at every opportunity. Because when they speak out, they speak for all of us."

ROS WYNNE-JONES, REAL BRITAIN COLUMNIST

SUPPORTED BY

"*This is a class that have everything taken from them and are then derided for the want of it: denied a functional education they are typified as ignorant, robbed of their jobs they are called benefit scroungers and, while effectively silenced in any cultural or social debate, are seen as inarticulate. This magnificent and very timely book puts the lie to that with its sensitive portraits – some inspiring, some heart-breaking, some both at once – of a diverse, various and above all resilient people who, when given a voice, have stories that urgently need to be listened to. This is a profoundly important human document, haunting for all the right reasons, and must be read.*"

ALAN MOORE, WRITER

ACKNOWLEDGEMENTS

Thank you to everyone who supported *Invisible Britain* by contributing to our GoFundMe campaign. Without you this book would not have been realised. We would also like to thank the following people:

Jamie Burton, Tony Colville, Vanessa Crawford, Rufus Dayglo, Stephen Dillon, Anna Doyle, Yolanda Fernandes, Michael Garrad, Helen Goulden, Jo Greig, Richard Guy, John Higginson, Bert Hogenkamp, Graham Jones, Mike Kelly, Kathryn King, Nick Levett, Gaynor Lloyd, Tim Mahar, Ravi McArthur, Chris McEvoy, Lisa McKenzie, Jessica Miles, Hilary Morison, Lesley Nichols, Chris Norbury, Mickey O'Brien, Graham Peet, Dawn Rushen, Lucie Russell, Alison Shaw, Michael Sheen, Tony Shephard, Valerie Sng, Lisa Stepanovic, Rebecca Tomlinson, Chris Wilson and David Worth.

Special thanks: Arthouse Crouch End, Four Corners, Renegade TV and Barbara Weed.

FOREWORD

*"People don't want to be felt sorry for;
they just want to be heard."*

MARIE MCCORMACK, GLASGOW

Ask people if they could have any superpower then what would they choose and pretty high up the list would come invisibility. To move unseen, unheard, no one aware of your existence. The freedom to observe whilst being unobserved yourself. Leaving no trace and no witness. Of course, this is with the assumption that you are in control of your own visibility or otherwise. That you still have agency. To have invisibility imposed upon you with no guarantee that you will ever be seen again is another thing entirely. Invisibility is not disappearance. As I write this, there is a video online that has, at last count, had 14.5 million views of a guy doing a magic trick using his unwitting younger brother. He covers the boy in a sheet, then in a room full of expectant friends and family members, he removes the sheet with a flourish and, lo and behold, the boy has disappeared. The rest of the family are in uproar, shocked and amazed by the trick, calling out for the lost boy. The boy, however, is still there, looking on, bemused, as his family goes crazy in front of him. He is, of course, not invisible at all. It's all a prank, pre-planned, to trick him into thinking he can no longer be seen. A state of being that mere minutes before he might have dreamed of, fantasised about – but now he is tasting something of its reality. His bemusement quickly turns to distress, and soon he is sobbing, terrified, desperately pleading with his family to see him, to make them aware that he still exists. To once again be revealed as having presence.

This is a book of revelation, also. The faces in these photographs look out at us on an equal footing. Asking to be seen and heard. Not as case studies or statistics. People. Lives being lived. Each telling us a small but significant part of their story. Not as background colour to grit up a screen drama, or as council estate fodder for a tabloid scrounger story. These aren't the bit parts – today these are the heroes.

Not that they are some homogeneous lump of noble suffering. Privilege doesn't have a monopoly on complexity. There are many voices here, multiple, contradictory points of view – frustrated, hopeful, angry, scared, defiant, passionate, compassionate. There are things in these stories that are shocking. Things that moved me to tears. Things I disagreed with and things that are hard to accept. They get to speak for themselves, and be seen as they are.

Poverty porn it is not. As Reis Morris of Notting Hill says, '… poorness… that's not the reason. The reason is the system.' Marie, who I quoted above, says, 'We are all vulnerable.' She's right. We can all struggle no matter what our backgrounds or circumstances. We can all suffer, but some of us have access to meaningful, effective, well resourced support when we need it and some of us don't. These stories reveal communities where demand for support services is increasing but funding for them continues to disappear. And in this case it's very real, not some parlour room trick.

What these stories don't reveal are people passively bemoanin[g] lot and waiting for someone to rescue them. Many of these vo[ices] unflinchingly tell you what they have experienced and how it [has] them a burning desire to commit to helping others going thro[ugh] same. That is ultimately where hope lies. People helping each [other] help themselves.

One of the most powerful things that this book has left me wit[h] image of the children's faces in some of these pictures. They lo[ok at] us, direct, sober, expectant. They ask us a question – 'Will you [...] Will you dare to put aside your covering sheets and your tricks[...] your feigned shock and concern, and, instead, will you simply [...]

MICHAEL SHEEN

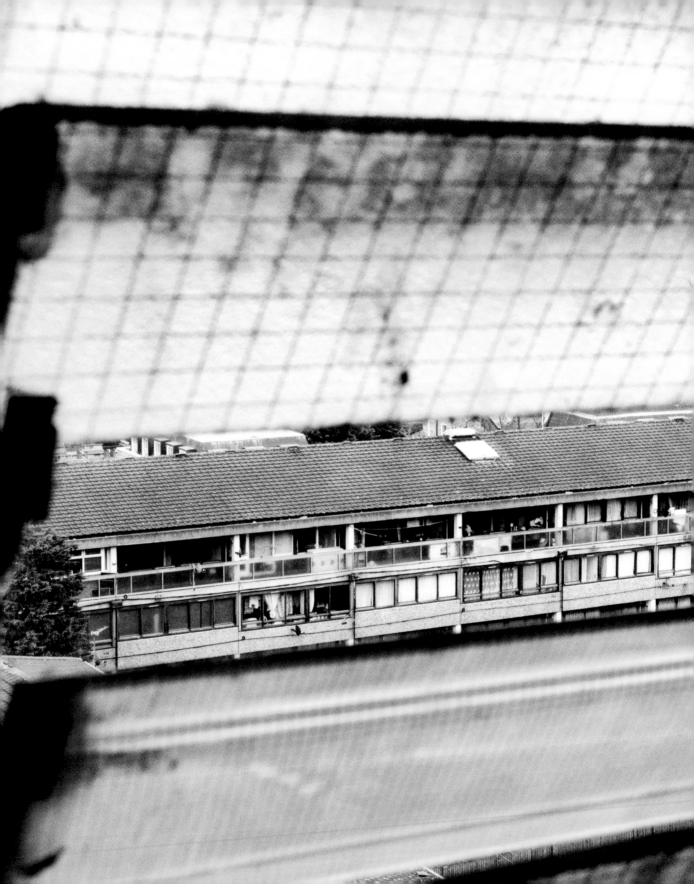

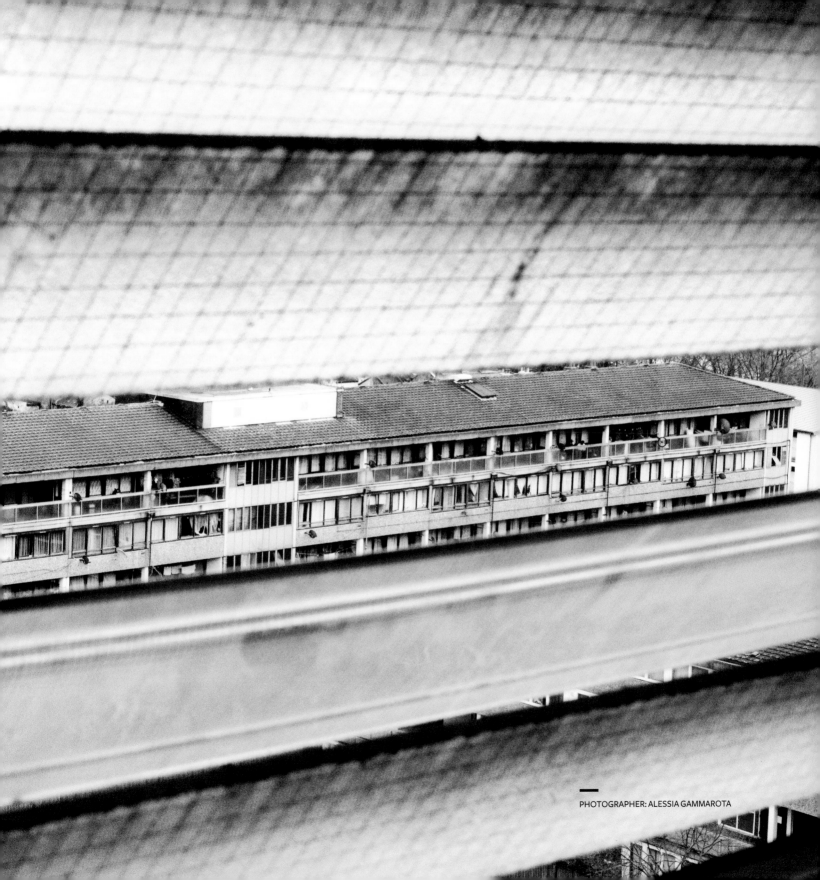

PHOTOGRAPHER: ALESSIA GAMMAROTA

INTRODUCTION

This is a book of stories that are rarely heard. It's a book about people who are often marginalised in the media, neglected by politicians, and ignored within society. It's a book about identity, injustice and inequality, and the social issues that are affecting millions of people across the UK. Most importantly, it's a book about how people have found hope among the ruins and survived through difficult times.

The idea for this book arose from a documentary I co-directed in 2015. *Sleaford Mods – Invisible Britain* followed the Nottingham band Sleaford Mods on tour in the run-up to the 2015 General Election, visiting some of the neglected, broken-down and boarded-up parts of the UK that many people prefer to ignore. In each town or city we met with local people and asked how unpopular government policies had changed their areas and what, if anything, they were doing to resist them. To describe the people we met as 'ordinary' is to do them a disservice, given the extraordinary efforts they had taken to protect and preserve their communities. From Stockton-on-Tees to Southampton, Barnsley, Lincoln and many other neglected pockets of the UK, what we saw wasn't 'Broken Britain', but rather the front line of nationwide resistance.

On 23 June 2016, the British public voted to leave the European Union in a referendum that divided the UK. The political earthquake shook the foundations of Westminster, but the shocks extended far beyond London to show communities reeling from blows that had begun with the unfettered neoliberalism of Margaret Thatcher's Conservative government in the 1980s. To some, the vote was characterised as a case of forgotten people striking back at a political class that seemed determined to leave them behind.

In December 2016, I started to think about how a book of portraits and stories might serve as a vehicle for people whose lives have been blighted by government failures and neglect to have their say. The idea was developed to focus on people affected by social issues including austerity, deindustrialisation, housing, welfare cuts, and the rise in nationalism and xenophobia. In consideration of John Grierson's formulation that documentary is 'the creative treatment of actuality', each story is told by each person in their own voice; less ethnography and more direct testimony.

Marginalised communities are rarely heard from in the mainstream media. It took the Brexit vote for politicians to take notice of the anger and frustration in areas that voted predominantly to leave the EU. In some respects, the EU referendum was also a referendum on the poor state of public services, the lack of affordable housing, and a protest vote against the government. In his report *Did Austerity Cause Brexit?* Thiemo Fetzer suggests that government austerity policies directly led to the UK voting to leave the EU. 'The fiscal contraction brought about by the Conservative-led coalition government starting in 2010 was sizable,' he writes. 'Aggregate real government spending on welfare and social protection decreased by around 16% per capita. At the district-level, which administer most welfare programmes, spending per person fell by 23.4% in real terms between 2010 and 2015, varying dramatically across districts, ranging from 46.3% to 6.2% with the sharpest cuts in the poorest areas.'

The assumption that the people who voted to leave the EU were 'stupid' and 'ignorant' misses the point. Politicians were in dereliction of their duties by failing to pay attention to the concerns of people

in areas that have suffered for decades. Furthermore, the sweeping accusation that Brexit voters were motivated by racism and xenophobia is restrictive and requires further unpacking. The rise in nationalism and the popularity of right-wing figures is troubling for many reasons. However, unless we are willing to examine and address the root causes of why sections of the disenfranchised are being seduced by far-right ideology, we risk empowering those in positions of influence to manipulate even more people. Empathy, meaningful conversations and open debate are crucial. People need to feel that their voices are being heard. We should all listen more.

Some of the people featured in *Invisible Britain* are grassroots campaigners who work outside of Westminster or local politics. Their politics take place on the streets, and many have been incredibly effective in working to resist austerity and in campaigning against injustice. Many of the people who tell us something about their lives in these pages have been ignored or misrepresented in the media, or feel out of sync with the government and politicians. *Invisible Britain* is designed to amplify their voices. It's also a reaction to the poverty porn narrative that has come to dominate how people view those on lower incomes or who claim benefits. Negative and stereotyping narratives encourage the public to adopt detrimental opinions about council estates, benefit claimants, migrants, refugees and other minority groups. Though it's not intentional, the damage done by programmes such as *Benefits Street*, *Skint* and *On Benefits and Proud* is immeasurable; they stigmatise not only people who claim benefits, but also people who live in social housing, making it easier for politicians and property developers to demolish council estates altogether.

This collection isn't designed to be a comprehensive and definitive representation of modern Britain, but rather to provide a snapshot. We avoided going for sensationalist tales in order to focus on the politics that occur in people's daily lives, and their hopes for the future. Many of these stories are from individuals who have been affected by the decisions made by politicians, so we felt it was important to include a range of political views, including some that I personally don't share. We also wanted to include new and emerging photographers alongside those already established in documentary photography.

The book is intended to be the first step towards creating a platform called Invisible Britain, which will work with individuals and communities across the UK to bring unheard voices to the fore. We want to enable people from disadvantaged backgrounds to tell their own stories directly across the visual arts, and help them to find a way into the creative industries.

I am deeply conscious of a debt of gratitude to everyone who contributed to producing the book you now hold. The first and greatest debt is, of course, to the people who shared their stories. Secondly, to the photographers who contributed images. I am also indebted to our curator Laura Dicken and the team who worked on the book, and I would like to thank them for their energy and diligence in seeing the project through to its completion.

PAUL SNG, SEPTEMBER 2018

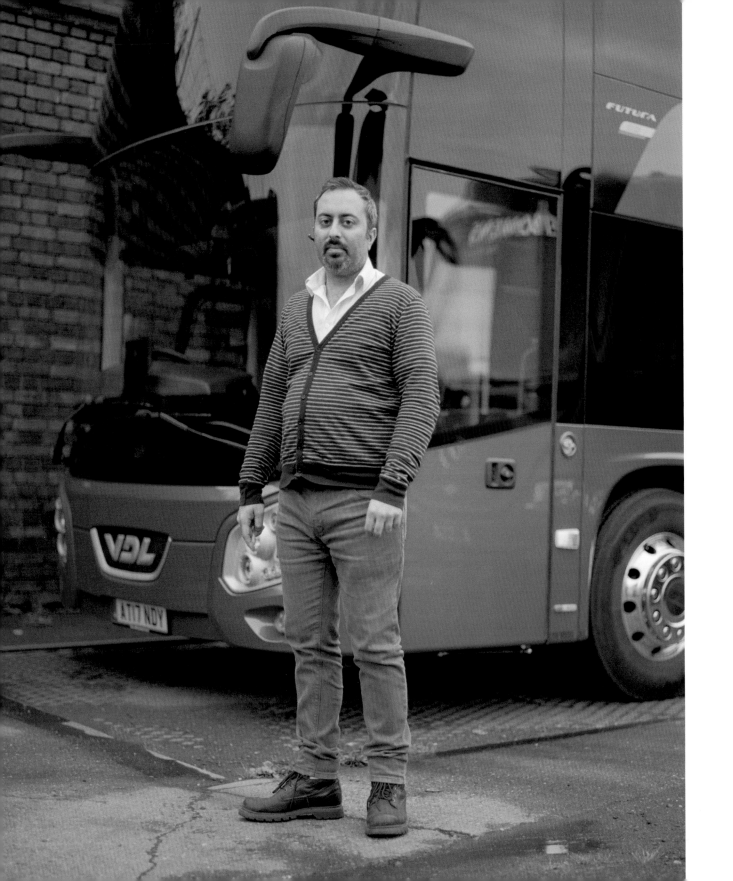

Avi Thandi
Birmingham

Immigration has completely changed the city. There's a thriving community of Asian people.

I was born in Toronto, Canada, but grew up in Birmingham and have lived here my whole life. When I was growing up, the area had a lot of elderly white British people. Immigration has completely changed the city. There's a thriving community of Asian people. They've built up shops and restaurants and there's a particular energy in the streets. Most recently, there has been a growth in Eastern European communities, who have come to Birmingham to work.

As I kid I went to quite a white school in my neighbourhood, so I used to get people saying 'Paki this, Paki that'. I got used to it very quickly, so it never used to bother me too much. It doesn't happen so often any more. I feel integrated within the community, as we have all grown up together and we've known each other for years. That's now starting to change; people are moving outside of the area, to build homes, in quieter neighbourhoods or outside of Birmingham.

My dad started Thandi Coaches and I've been working in the family business for 20 years. It was set up initially to service the Asian communities in the UK – typically, between areas such as Southall, Birmingham and Bradford. We set up these routes at a time when no other transport links were available. It has connected major towns and communities. Things have changed quite a bit as we have grown. We've now started marketing the service to many other communities, such as Eastern European, black and African communities. We do corporate bookings, weddings, school services and holidays.

I feel that Britain feels like a worse place today than when I was growing up. There's too much crime in the streets. Young kids, just 16 to 18, carrying knives, hanging out in gangs. There's been an increase in armed robberies; they just grab anything they can for free. As a result of the cutbacks to the police, we have less of them servicing our community, and they aren't quick enough to respond to crime. It's sad, it's become a mindset for these young people and it happens because of a lack of opportunity for them as they are growing up.

I think we've had too much immigration in this country for too long. We need to make sure we can help and provide for our own communities in the UK. Of course, it's horrible what's happened to the people affected by the Windrush scandal – these people have worked all their lives, settled down with families, built homes, and this is how they've been treated.

I don't think Brexit has impacted our community really at all. A lot of people are frustrated in our town; they're switching their votes from Labour and voting for something different. I'm optimistic about Brexit – I hope it can reduce immigration and bring us a better, stronger economy that will make us a stronger power in the world.

PHOTOGRAPHER: VIVEK VADOLIYA

Billy McMillan
Easterhouse

If you say Easterhouse to someone, the first thing they think of is normally gangs, violence and drugs.

Easterhouse is the most geographically isolated suburb of Glasgow. It's seven miles from the city centre; literally the furthest point at which you are still in Glasgow. It's wedged between the M8 to the south and the countryside to the north. It feels like it should be a separate town and not part of Glasgow, 'cause many people here don't identify with the city. I'd say I'm from Easterhouse rather than Glasgow.

My family were amongst the first people to be moved into this area. I was born in the old Easterhouse, when the gangs were still a major power. Violence and drugs were much more prominent then. If you say Easterhouse to someone, the first thing they think of is normally gangs, violence and drugs. At one point that was the reality, but it's never been predominant. You're looking at roughly 120 people at any given time who were involved in that. There are 5,000 people that live here. When you tell people you come from Easterhouse – and they think you're possibly going to stab them – that's an immediate misunderstanding.

It's easy to say that Easterhouse is a better place now than it was in 1999 when I was born. Drug use has stagnated a wee bit recently and the gangs have disappeared completely. Houses have been knocked down and rebuilt. Most of the schools have been knocked down and rebuilt. I've seen the area change from a new town to what now resembles a traditional suburb. You could argue that this transformation is responsible for the decline in culture. It's responsible for the decline in drug use, but most of the issues that were in Easterhouse before the gangs are the issues that caused the gangs, and are still present: sectarianism, child poverty, unemployment, health…

There's the view that progression is a good thing, and then there's a sentimental attachment to the past. In many respects, progression in the housing developments has been for the best. Most of the houses that were pulled down here didn't have central heating or indoor toilets. But it feels like a backhanded attempt to raise property prices. Easterhouse was built for 40,000 to 50,000 people and there's now less than 5,000 here. Most of the people moved on, which is just a general trend of gentrification.

There was the belief in the 50s and 60s that by moving people to the greenbelt they might become healthier and get the soot out of their lungs. Traditionally, once an area industrialises, the middle and upper classes move out to the suburbs, while the working classes remain in the inner city. In the 60s and 70s the plan seems to have been to move the working classes out of the inner cities and move the middle classes back in. There was no way for people to travel from Easterhouse to the city centre; there was no regular bus. There's no amenities here. There's no jobs. It felt very much like the area was set up to fail.

I'd like to see a better education system in Easterhouse. I'd like to see more employment opportunities, more community opportunities and better housing. Building the most appropriate housing for the people here, as opposed to simply building houses that appear on the surface nicer and newer or fancier.

PHOTOGRAPHER: KIRSTY MACKAY

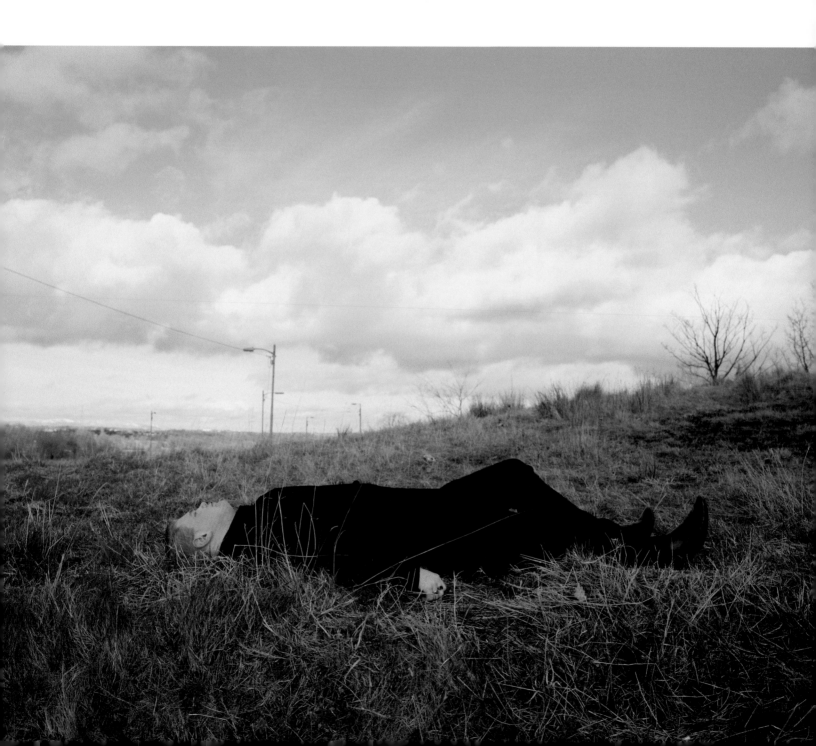

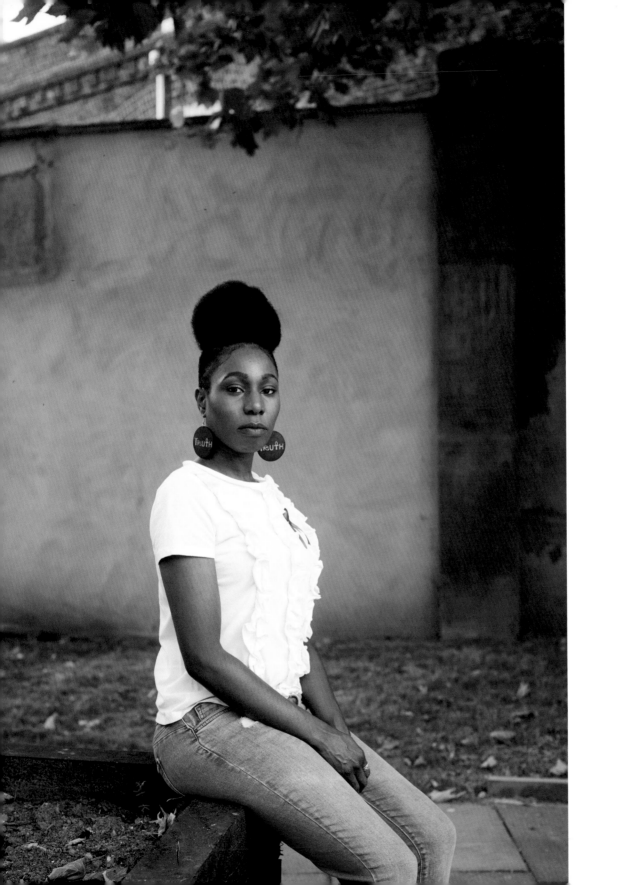

Corinne Jones
North Kensington

There was a family on my floor: a mum, dad, sister and two brothers. None of them made it out.

I lived in Grenfell Tower on the 17th floor. It was my first permanent property in 10 years. Everything was temporary before that. I never felt comfortable sleeping in my room. I never thought of a fire, but the silver cladding on the building just reminded me of the Twin Towers. In the night, I used to wake up sometimes just thinking something would happen, and have that panic inside of me.

There was a family on my floor: a mum, dad, sister and two brothers. None of them made it out. The older brother had moved out a few months before because he got married, so it's just him now. No brothers, no sister, no mum, no dad.

In the week after the fire, we were put in a single hotel room for the four of us for one week. I had to fight to get out of that. I went down to Royal Borough of Kensington and Chelsea council offices on the Friday to complain, and was told to wait until Monday and they would sort it out, which I refused to do. Luckily, I had a good key worker that was able to fight our corner and get us a hotel that had two interconnected double rooms.

We were there for just under six months. There was no kitchen and we didn't even have a microwave inside the room. It was a pretty expensive hotel, so you'd have some people in there that had money. It just didn't feel right to be sitting down with people who were on their holidays. We never ate dinner at the hotel, because the food that they cooked wasn't food that the kids were used to eating. And I had to go to my mum's house every day after school just so the kids could do their homework.

There are people that are still in hotels. The council told us in November that we could choose a temporary property as long as it's within a certain price bracket. I chose about 15 properties. Six weeks went by and nothing had happened. So I had to get in touch with a housing minister, after which I received a call from the council to say they'd got keys to a property for me to come and view the following day. I then moved in two days later. That's what we have to deal with

to actually move forward in this situation, because if you just relax and expect them to do their work, they're not going to. You have to fight with them for everything and keep putting pressure on them.

We moved out of the hotel and into temporary accommodation at the end of November, but we still don't know where we're going to live in the long term. In February we were offered a flat I was happy with, and I tentatively accepted it based on fire safety and electrical checks being done. We were meant to move in there in May, but the flat failed the fire safety check. The checks should have been done before we even saw the properties, before they were even offered out to us. It's like a numbers game, so that they can say 'We've got another family that has accepted a property'. It looks good on their books.

Now we're back at square one. I've got to accept that's not the house we're moving into. I'm not sure what's next, but I want our next move to be permanent. I didn't even want to move into temporary housing, because I didn't want to have to go through the rigmarole of moving again.

As much as we can talk about the events of what happened the night of the fire, we are still in a fight. We are still at war. I've asked the council what type of training have the senior staff members had? Because it seems like they are not trained to deal with us. Sometimes they take it really personally and I don't think they should, because we are upset and quite rightly so. A lot of times you can see them not being able to handle the situation in a good way.

The people responsible for the numerous different failings, from the windows that were made out of PVC, to the cladding that had polystyrene in it, need to go to jail. Everything was combustible. And on top of that, they underspent on the whole refurbishment. The senior members in the council were putting pressure on them to make sure that they underspent, in a borough that has the most amounts of money reserves in the whole of Europe. It's just so insulting. I wish I didn't have to deal with them at all. But we have no choice.

PHOTOGRAPHER: JENNY LEWIS

Dan Kilifin
St James, Belfast

The land was just sitting there and the idea came up about making an allotment on the bog land, so that the people in the community could grow their own fresh food.

During my childhood we had the conflict in the North. Every day you'd hear about people being shot, killed, or attacks happening across the city. You'd be searched on the street, especially being from a deprived area such as west Belfast. But even with everything that was going on, the community of St James was still very close-knit. People left their doors open, people wandered in and out. If you needed some milk or sugar, you'd rap the neighbour's door. It's still very much like this today. Everyone stands behind each other in the community, but there's never been much here for people to do.

The farm happened just out of a conversation one day with my mate Limbo, Damien Lindsay. The land was just sitting there and the idea came up about making an allotment on the bog land, so that the people in the community could grow their own fresh food. We had a few volunteers from the Simon Community come down and help put up the fences. They still give us a hand every day.

It's great for St James to have the farm. We've grown a lot of vegetables and every day we check for hen and duck eggs. All the produce we grow is given to the elderly or those in need within the community. It saves them going to the big stores and spending a fortune. The kids love it and it also gives them an understanding of caring for the animals. They help with the daily feeds before going to school or at the weekend, giving up their time to help with the clean-ups.

We still have problems with unemployment in the area, so at the farm we take on volunteers to give them the skills they need for work. They help with the feeds, building sheds and cleaning up, and it gives them a buzz when they see the work done and the animals enjoying it. We also invite people who are going through a tough time to come here, help dig holes or repair sheds – something that's going to take their mind off stress.

We've been trying to do more for those going through a hard time by offering them night classes to learn the Irish language, join the walking group and the fishing and football clubs, but more needs to be done. I hope our efforts continue to inspire other communities around Belfast because, let's face it, if we sat waiting for the governments to help us, we'd all still be waiting.

The farm continues to fight against homelessness in the area and is also helping those going through hard times with mental health, drugs or alcoholism. It's a place you can go, chill out and clear your head. We're able to help those who need it most. Local people can come, grow their own fruit and vegetables, learn how to live off the land, but more importantly, have fun with being outdoors. The community has had its fair share of hard times over the years. Last year was tough because of the rise in suicides in the area. We encourage those who are going through hard times to come and share their day with us. I hope that we can continue to offer the support programmes and keep helping those who need it most.

PHOTOGRAPHER: JAMES MCCOURT

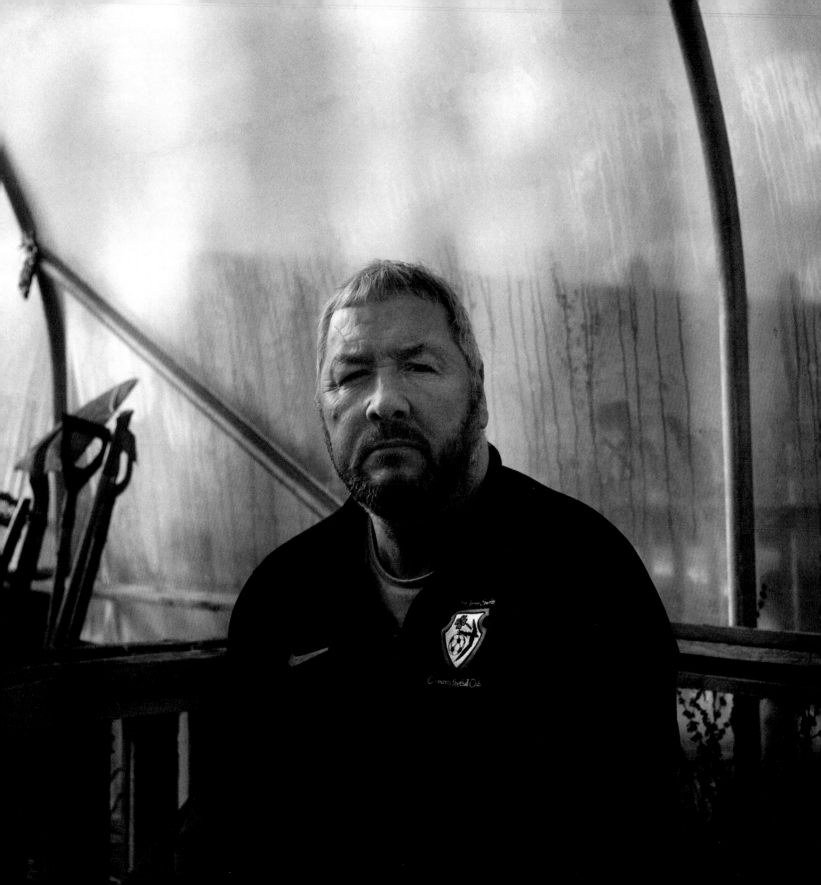

Living a life that is affected by austerity feels like a judgement from a Tory government of who I am. I don't feel that there's anybody looking out for my interests as a human being.

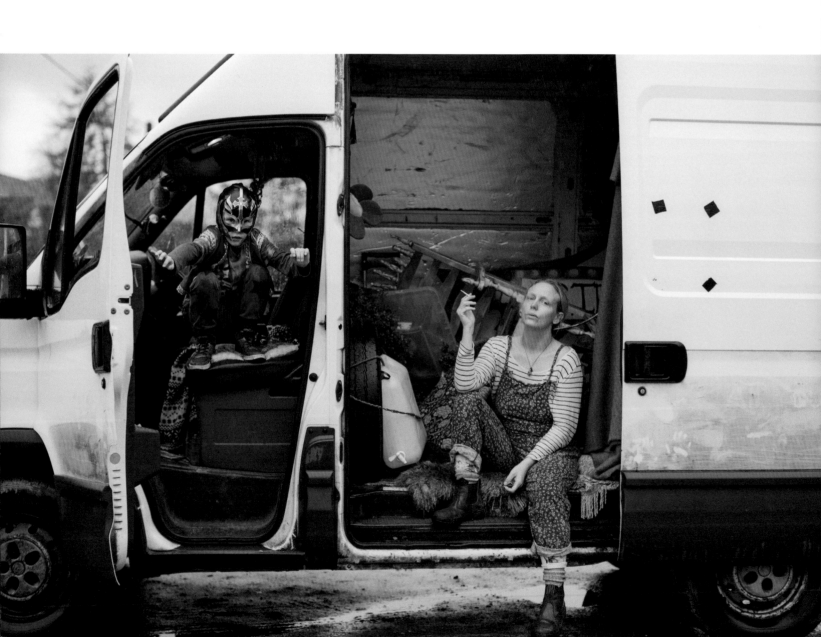

Emily Green
Long Melford

I was born in Chelmsford in Essex and grew up in Heybridge, near Maldon, on a council estate with my mum. I remember a girl who went to my school. Her parents were both artists and they talked about her going to university. It was worlds away from my life. I wasn't told that I could be anything.

Living a life that is affected by austerity feels like a judgement from a Tory government of who I am. I don't feel that there's anybody looking out for my interests as a human being.

I don't recognise any of the things that Theresa May says. They don't make any sense to me. They don't seem to apply to me. Everything that she talks about seems to be against me. My mother's got an extra bedroom, so she has to pay the bedroom tax. My mum's got nothing. I don't actually know how they survive. They don't really eat very much. It makes me really sad. My mum paid her taxes, she had a good job when she was younger, and now she's living this life where she feels like she's got nothing. I talk to her about not voting UKIP or Conservative, 'cause she reads the *Daily Mail* and believes it. I tell her it's full of lies. But there's a whole bunch of people my mum's age that are just swayed by the stuff that they read in the media.

At the last election, I really had to explain to my mum that the people she was voting for, or thinking of voting for, have brought in the bedroom tax. I explained that they're stopping child benefit for more than three children, unless you've been raped. And then you've got to prove that you were raped. Mum was like, 'No, that can't be right'. I had to really say, 'Mum, don't do it'. And she went and voted Labour.

I've had to work really hard for everything that I've got now. I've met a lot of inspiring people that have believed in me. I was a really good youth worker – a lot of people wanted me to go into social work. I'm so glad I didn't. Working in the system like that, it's not for me. I meet people, kids, every day that might not be achieving or might be living under the poverty line, and social workers and establishments, they want to tick boxes with these types of people. But they're real human beings. They've all got hope.

As a performance artist, I love working with children. I feel like I'm a child trapped in an adult's body, so I can connect with them in a way that's energising. I get real joy from working with kids who, for whatever reason, might not get access to pens, paper or whatever, and encouraging a different way of thinking or being, a new way to express themselves through dance or dressing up. Sometimes as parents we have to overlook these simple things because we're so focused on just 'existing', getting by and surviving. I get kids coming through who don't have much, whose mum may be tired and worn out, and I can provide a relief – they're kids who grew up like me and I can feel that need to escape into fantasy, and that's a real privilege.

Some people might categorise me as a children's entertainer. I don't care too much how I'm labelled, because all that matters is that visceral connection and the reaction that I hope will shape or plant an idea that these kids can be whatever they want. It doesn't matter where they come from.

PHOTOGRAPHER: POLLY ALDERTON

James Douglas
Doncaster

When I first found out I had MND, Steph had just given birth to Ralphie, so we went from that amazing high to being told that I'd got something that could potentially kill me in two years.

We were on a family holiday when I noticed that my hands were starting to curl and lose feeling. When we got back we went to the doctor, who took me to a hand specialist. I was seen by a neurologist at Doncaster Royal Infirmary. My reflexes were off the scale, which is a common thing in Motor Neurone Disease (MND). The old analogy with the doctor banging the hammer on your knee? My reflexes were off the chart.

I worked in the gas and electric metering industry, on the smart metering side. I'd good prospects: I went from office manager to business development manager, had a good salary and a company car on its way. But everything was taking double the effort. Stephanie had to help me get dressed in the morning.

I was told by the nurse there were benefits. We started the process in November 2017. You think, oh, super. Then they say, 'We're going to send you an application form'. Yep, fair enough. But to be hit with a nearly 40-page document, it's eye-opening. The document is exactly the same for everyone. Twelve questions classed as 'daily living', from getting dressed, getting washed and bathed, to toilet needs, cooking. Then there's a mobility aspect, asking how far you can walk, do you still use a car to get about, can you still drive? There's a guideline booklet which says, 'Don't just say "I cannot button up my shirt", go into detail as to why you can't button up your shirt.' We went into as much detail as possible. We thought it'd be a case of, yes, he's got MND, he needs to be awarded.

We received a letter from the Department for Work and Pensions (DWP) saying we needed to go to an assessment in Doncaster, which, for people with MND, shouldn't happen.

The DWP guidelines state that anybody with a terminal illness should be granted benefits straight away. The assessor said he'd worked in nursing for 10 years, but it was obvious from the outset that he didn't know what MND was, what it did, and what it affected. We gave him an outline.

He got into his assessment, and believe it or not, asked exactly the same questions that were on the form. We'd spent a good four hours on it, only to then spend an hour-and-a-half with him asking the same questions.

We received a letter saying I'd scored zero in every category. They'd seen twos, and threes and fours before, but never zero. The report was pretty damning. I was made out to be a liar. It stated that I could walk over 200 metres unaided, even though I walked into the room with a walking stick. Because I maintained eye contact and we had a good rapport, I was judged to be of 'sound metal health', which I find amazing. Some things were just factually wrong. He said I drove for a living when I'd stated that I drove to and from work. Had he got mixed up? Had he made a grave error? It was as if Stephanie and I had given the answers to a different person.

When I first found out I had MND, Steph had just given birth to Ralphie, so we went from that amazing high to being told that I'd got something that could potentially kill me in two years. They're 70-80% sure I'll live a lot longer than most, because of my age. But there's only one licensed drug in the country, which only slows it or stops its progress, for five months, maximum. There's no other thing. It's care rather than cure.

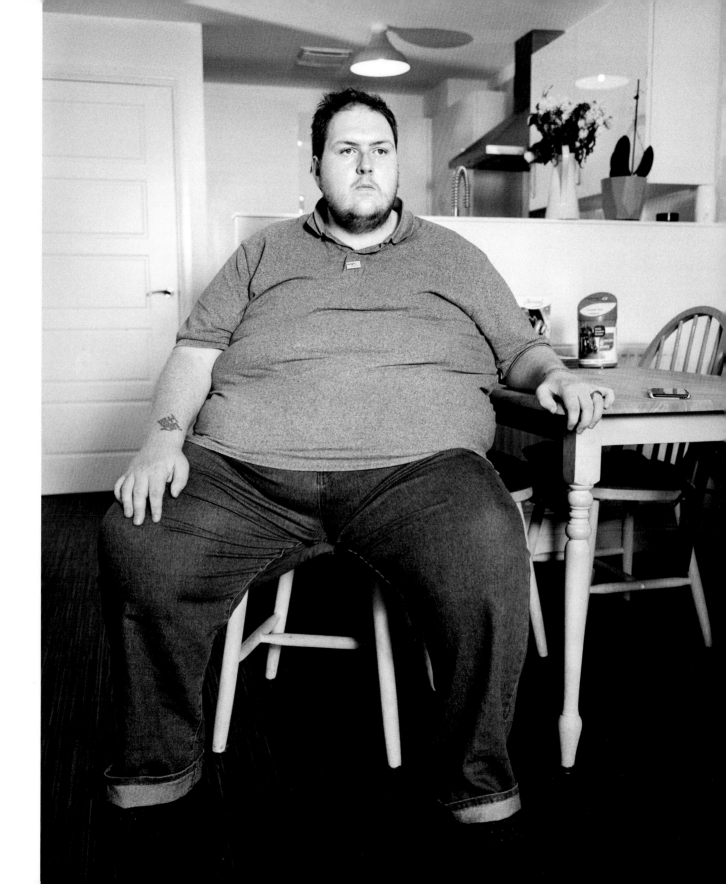

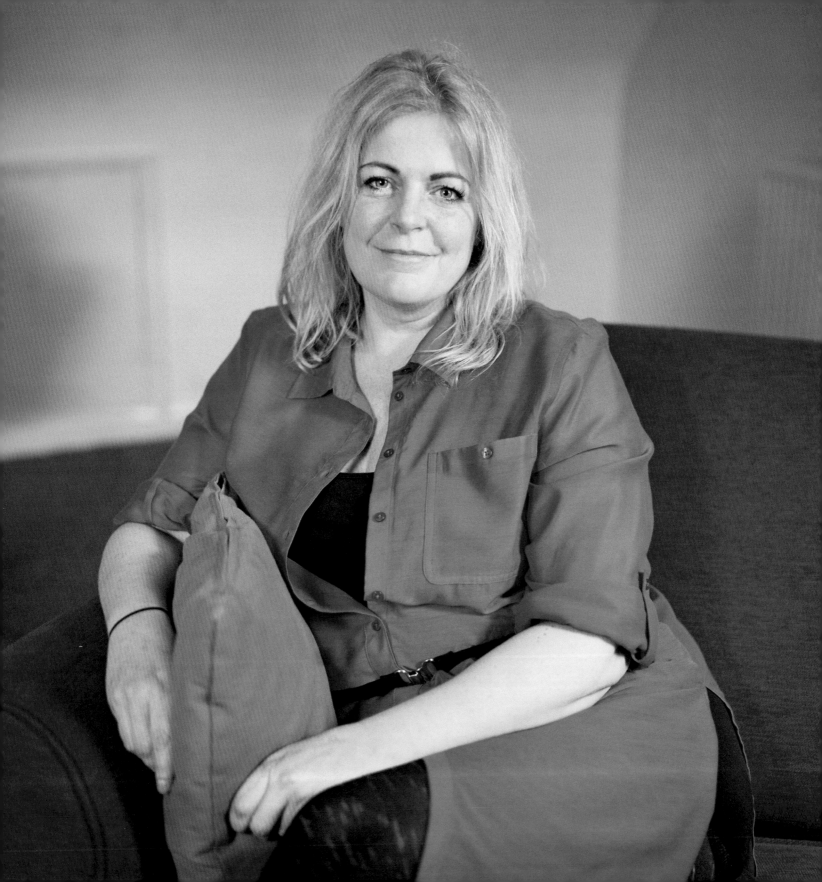

Jay Ryan
Monmouthshire

I felt like a little invisible shadow. People knew, but I couldn't tell anyone, as I was so scared that my child would be taken away. I thought if I kept my mouth shut, then at least I had my daughter.

I grew up in Cwmbran and knew nothing of domestic violence until I met my future husband at the age of 15. I was locked in his flat and prevented from going to school. I fell pregnant at the age of 16. Things gradually got worse from there. In the following seven years I was continually punched, kicked and bruised, even when pregnant. I had knives held to my throat, bleach poured over me when bathing, my clothes ripped off me in public, was shot at with a pellet rifle, and drugged to keep me compliant and physically imprisoned. Threats to kill me, my daughter or members of my family were a daily occurrence. I was 23 and had lost my family, lost my laughter, lost the sparkle in my eyes. I felt like a little invisible shadow. People knew, but I couldn't tell anyone, as I was so scared that my child would be taken away. I thought if I kept my mouth shut, then at least I had my daughter.

The trigger point came when he started to mentally abuse my daughter. She was petrified of him and repeatedly asked to be taken away to a happy house. One day he was injecting with one of his mates whilst I was locked in an outhouse cupboard. I managed to push my way out and just ran. All I had was my child benefit book. With my younger sister's help we collected my daughter from school and went straight to the local Women's Aid charity. They brought me to this very room in this very refuge in Monmouthshire.

My life started the day I left him. I went to performing arts college, learnt to drive, did a degree, and slowly forged a career in working with children. It is only over the past year, since I got my job at Cyfannol, that I've managed to really ground and distance myself from the girl who turned up at this refuge in all her utterly broken state.

I see and feel the transparency and invisibility in the women who come to Cyfannol for the first time. I recognise the turmoil in their minds, the not knowing where they fit in. It's my role to work with them, and primarily their children, and help them rebuild their lives. It's a specialist position, being one of only three in the whole of Wales. I deal with children who are traumatised and who are emotionally numb, and it's my passion to bring them to life again.

I've been involved in a mentoring capacity for over 10 years and have witnessed serious cutbacks in overall funding during that time. The current period of austerity has not only resulted in a reduction in the number of refuges for women, but also impacted on legal aid entitlement and mental health service provision. Whilst rates of domestic violence are increasing in the region, there's no extra money to cope with the demands on our services. The lack of a holistic approach at national governmental level means we really are at breaking point. Cutbacks in the police, education and health all impact on our ability to rebuild the lives shattered by domestic violence. My post is only funded for another 12 months. It means that we're unable to plan for the mid term, let alone for the long term. For the women and children who experience domestic violence first-hand, the physical and mental consequences are there for years afterwards.

I really hope that in the future we invest in our children's education, wellbeing and mental health. That we emphasise positive relationships and address the growing fragmentation in our society. That domestic violence, both physical and mental, is confronted openly and debated seriously, and is no longer hidden away behind closed doors.

PHOTOGRAPHER: JOSEPH MURPHY

Myles Evans-Reid
Handsworth

Even as a kid going to school, I felt like teachers had a handbook on how to deal with particular kids when it came to race. They're so quick to kick us out of school.

Handsworth is very diverse and there are a lot of Afro-Caribbean people here, including me. My grandparents on both sides were born and raised in Jamaica and they came here in the early 1960s.

The area is changing a lot now the Eastern Europeans and also people from Kurdistan, Iraq and Iran have come in. I don't have an issue with it; a lot of them have come from the same struggle no matter what colour they are.

I know some people who have come here in recent years who have already gone back. I asked why and they said, 'They don't want us here'. I told them they didn't want my grandparents here and if they'd went back home I wouldn't be here. Others have come here just like they did – forget what we look like. Irish people will tell you the same thing; they didn't want them here. They only live across the water from us and they treated the Irish almost as bad as Africans back then.

I feel that Britain wants to leave the European Union and be this 'Great Britain' again; they want to get rid of people who have done a lot to build this country up. For Britain to go it alone they're going to have to get immigrants, they'll have to go back to the Commonwealth again. I can't see us standing on our own two feet without having to open up the borders.

I reckon once Brexit goes through you will see an increase in migrants coming in; they'll have to let people in. As much as they think they won't, they will.

It won't benefit me, but is it going to improve my kids' lives? Only time will tell. I think it'll be them that it'll affect because they'll be growing up in that period of time.

I experienced a lot of institutional types of racism as a teenager. Between the ages of 16 and 19, in one period I was stopped five times by the police, two times in one day on one particular day, but it was always at least once a week. Even as a kid going to school, I felt like teachers had a handbook on how to deal with particular kids when it came to race. They're so quick to kick us out of school. Apparently we aren't good academically; the only thing we do well is sports and music. I think if there are more of us who are doing good academically, then we can see that we have a broad range of options, but we only ever see sports and media TV stuff.

I have two girls and I don't really want them to go through what I've been through, yet I know they're going to encounter something, so I try to prepare them for what they might encounter as they become teenagers.

People were a lot more racist to your face back in the 70s and 80s, and even right up to the 90s when I was a child. What's happening now, it was happening then, but it seemed a lot worse; it seemed a lot more 'in your face'. To me, now, it's the same thing, just covered up with a smile, but I'd never change where my family have come from, I'd never change it for the world. I am very proud of my heritage.

PHOTOGRAPHER: ANDREW JACKSON

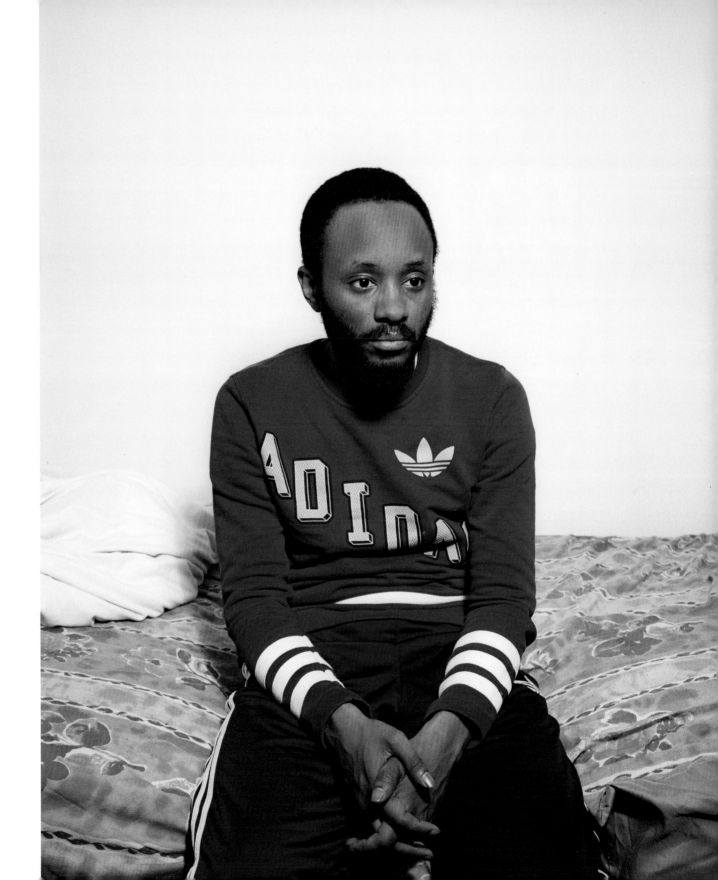

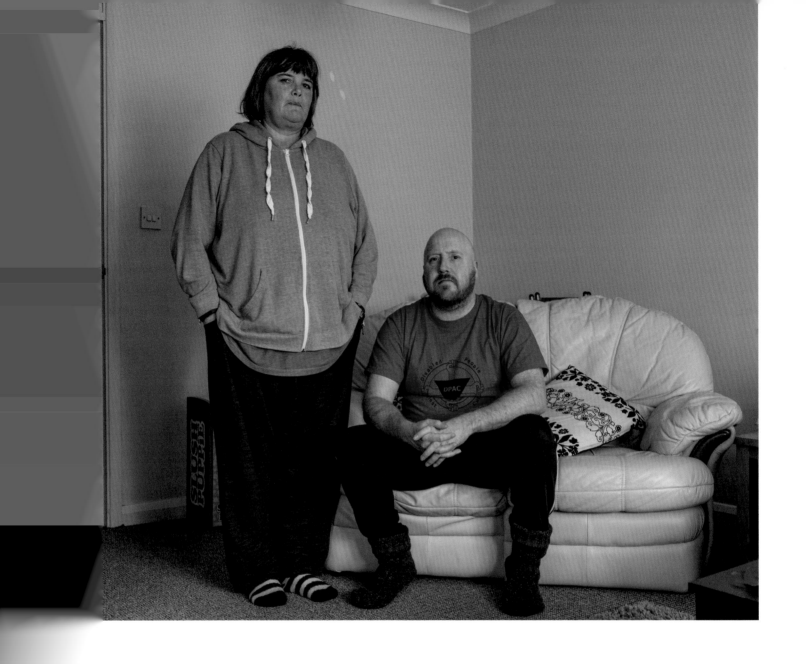

ampaigning with DPAC – Disabled
eople Against Cuts – gave me direction.
kept me going when I would've
ven up.

ULA PETERS

PHOTOGRAPHER: DEBBIE HUMPHRY

Paula Peters and Keith Walker
Orpington

Paula

In the last 12 months there's been 64,000 reported cases of hate crime against disabled people. MPs demonise us and the media call us shirkers and work-shy. We're on the receiving end of abuse when we go out on the street. I've been called a scrounger, a fraudster. We've been spat at. On a bus I was threatened with being punched.

When I got my letter to be reassessed for Employment and Support Allowance, I cried. Those forms are so ambiguous. They make you feel like you're not human. It's torturous, the financial insecurity and the hoops they put you through to prove you need support. You're in an abusive relationship with the Department for Work and Pensions (DWP) that you can't leave. You can't enjoy life or plan anything because they can take your money away tomorrow.

We've all been personally impacted by austerity. I've gone without food to pay bills and had hospital appointments cancelled. My friend, who had bipolar, didn't tell me she was going for the Work Capability Assessment. She was being hounded by the DWP, who made a mistake and said she'd been overpaid and owed them £26,000. When she failed the Fit for Work assessment she said, 'I can't deal with it.' She jumped to her death at Petts Wood station.

Campaigning with DPAC – Disabled People Against Cuts – gave me direction. It kept me going when I would've given up. ATOS got over £18 billion worth of government contracts and designed the Work Capability Assessment, making a vast profit. So we made badges saying 'ATOS Kills'. We raised awareness of how toxic this government is, how toxic these companies are. The only way they understand is when you trash their reputation and hit their profit margins. ATOS started having recruitment problems, their share price fell, and they had massive backlogs. Then in 2014 they pulled out of the government contract. People ask, 'Is activism worth it?' Yes, it is.

DPAC and other campaigners were instrumental in bringing about the formal investigation with the United Nations Convention on the Rights of People with Disabilities, which found that the government was guilty of grave and systematic human rights violations. We had to learn the law to change it and fight back. We want justice and we won't stop until we get it.

Keith

I've been working since I was 18. Security guard, contractor, road worker, postman… so many jobs. I liked my job as a postman, but I had a breakdown. Now you go for a job and tell them you've got anxiety and depression, but there's stigma.

I've had the Work Capability Assessment – it's harrowing. You just feel like you're on trial. I'd love to work. The DWP should be saying 'We're going to help you, we'll give you training and if it doesn't work out we'll look at it again'. Instead of when it doesn't work out – bang – you're sanctioned. And you could be sanctioned straight off at three months, six months or three years. How can you be sanctioned for three years? You'd be dead.

If you're on Universal Credit you've got to prove you're doing 35 hours of job searching a week. And it's all online. But not everyone's got access to the internet. Some people can only go to libraries to get online, but libraries are closing everywhere and in some they're stopping the amount of time you can have on the computer.

You see austerity all around you – it impacts on everything. I volunteer in a food bank and there's a lot of desperate people there. I met a carer there who was on a zero-hours contract and couldn't afford to eat. The big one was David Clapson. He was in the army. He had nothing in his belly when they found him. He had £3 in his bank account and he couldn't pay his electric. He was diabetic but he couldn't keep his insulin cold in the fridge. He went into a diabetic coma. But he had put all the letters from the DWP around him to say 'they've killed me'. The coroner said there was a link.

Compared to when I was younger, Britain's a lot more selfish. It's not Great Britain. It's not even mediocre Britain. You hear in conversations, 'It's all the immigrants' fault'. But if we didn't have immigration there would be no NHS. It's nothing to do with the immigrants. It's austerity.

Reis Morris
Notting Hill

The cranes are like big guns aimed in on us. We are surrounded.

I was on holiday when Grenfell Tower caught fire. My mum FaceTimed me that night. My sister was nine months pregnant and I thought she was going to tell me that she was going into labour. I answered and she was saying, 'Reis, there's a fire, call your friends.' That's all she kept saying. And then there was a loud sound and all I could see was the sky and my niece screaming like a peacock. Three people from my niece's school died.

I went to 17 funerals in total. For my friend's family, I went to five funerals in one day. He wasn't even in the tower at the time; he went in to save his family and then never came out. His mum, his dad, his sister, his brother and him – all gone. There were real heroes in that building, like his sister, who was 15 years old and his little brother, who was eight. They found their remains with the sister cradling her little brother.

It's been more than a year since the fire and we've had a media circus down here since the first day, but are we any closer to justice? I think we are further away now. It's time to be honest and say the media have not helped our cause. The narrative they are putting out has not helped us at all; in fact, it's isolated the area, it's distanced us. People from outside the area are thinking, 'Oh, there's some poor people that live around rich people that dislike the rich people', which is not the case. They're saying everyone to the left of us in Kensington is the reason for our poorness, but that's not the reason. The reason is the system.

There were so many beautiful people, strong people, and people that achieved amazing things to come out of that block. But all you will ever hear about is the poor people dying in the block 'cause they were poor. That is not the case. Rent there is about £700 a month, so it's like 'Who's poor here?' And no one died 'cause they were poor. They died 'cause of the system – nothing to do with poorness.

Austerity has been there forever. You don't see people burning in their house alive over austerity. You don't see cheap cladding put up over austerity. That is inhumane, that's greed. There's not even a word to describe that. This was just disregard for life. The system has things in place to make that possible. They just prioritised their pockets. I don't think they were thinking about people.

I'm just angry, man. I don't sleep. I smoke too much. I'm just tired. Because I never saw the fire, it doesn't touch me as much as other people. I don't know how my niece is happy; she literally watched her friend jump out the window. Her school is there and loads of people turned up to her school with no clothes on. My mum is finished now.

I see myself as a product of this postcode. My fear is when my daughter gets to turn 30, I can't tell her anything. I can't walk down this road and say, 'That's where your daddy used to…' because it's already gone. The cranes are like big guns aimed in on us. We are surrounded. It's not like I'm going to have made millions to leave for her, so I want to leave her with her dad being known, like me. My dad never left me with nothing, but I know I can walk anywhere in this area and someone's like, 'Your dad, he was such a cool guy, man', and they'll tell me a story about him.

PHOTOGRAPHER: JO METSON SCOTT

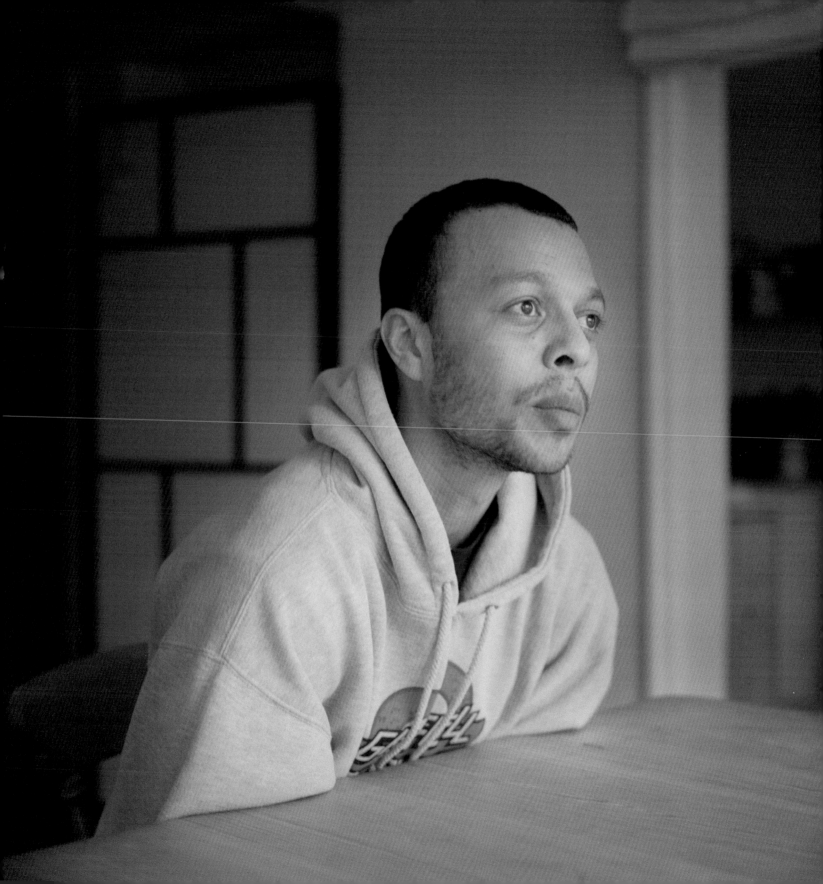

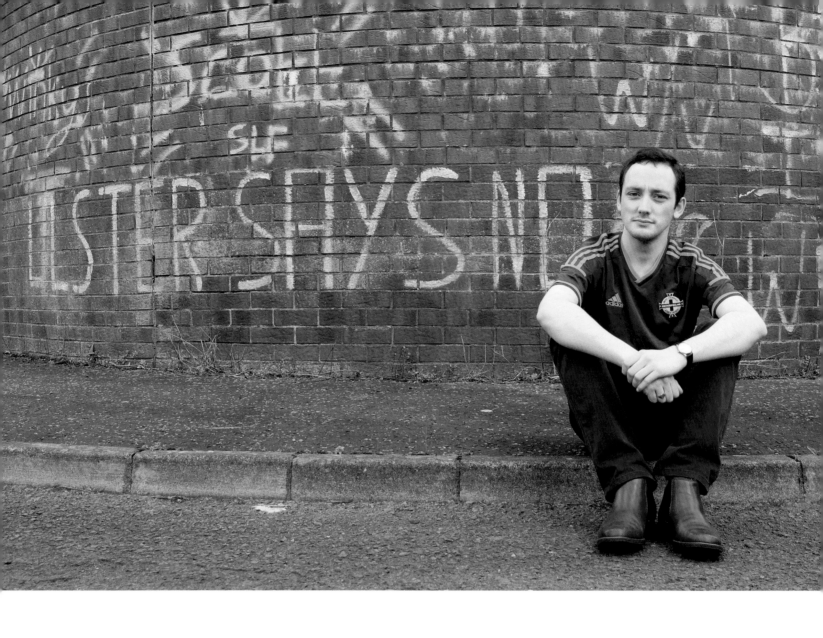

PHOTOGRAPHER: ANDREW JOHNSTON

Ross McVittie
Belfast

I feel the country is more divided. Maybe because of Brexit, but it feels like the gap has widened between left and right.

I live in east Belfast. George Best came from the east. The Titanic was built just down the road from me, in the Harland and Wolff shipyard, but like many industrial cities, over a period of time they start to decline. Belfast is a shadow of what it once was. I'm told by the older generation that once you left school, you were guaranteed a job in Shorts, the Ropeworks or the Shipyard. Things are different now. It's much harder to get a job.

I'm a DUP supporter. I know that's probably very unpopular over on the mainland, but I think a lot of the people over there don't really understand the DUP and why people here vote for them. The next biggest party over here is Sinn Féin. They have members in their party who are IRA terrorists and have been convicted of murder. Now that the DUP are in a coalition with the Conservatives, I think it's a good thing. A Northern Irish political party now has some influence in mainstream British politics, which is long overdue. We've secured £1.5 billion for Northern Ireland. That will be put to great use.

Currently I'm in education and don't have a job. However, austerity from the UK government has had an impact on my community. There have been far too many cuts and everyone's feeling the pinch, particularly in working-class areas, if the unemployment figures in east Belfast are anything to go by.

I feel the country is more divided. Maybe because of Brexit, but it feels like the gap has widened between left and right. It seems more polarised. But then again, there have been a lot of changes within Britain in the last 21 years. Mass immigration, harsh austerity, the dramatic rise in terrorist attacks, increased Islamophobia, and, dare I say, Christianophobia.

I'm hoping the UK will prosper when leaving the EU. Maybe we can start controlling ourselves instead of another country making decisions that affect us. I fear that there will be a further rise in terrorism and increased violation of free speech. I sometimes feel decent people can't express concerns about their country without being labelled as something they're not.

I'm not sure yet how it will improve the lives of me and my family. When I considered my stance regarding this referendum, I thought more of my community and where I come from. East Belfast was the only part of Belfast that voted Leave. This area was once an industrial heartland. A lot of the industry that was once here has now gone elsewhere. A lot of the big industries are owned by foreign countries.

Society in Northern Ireland is still very divided. Unionists, who are mainly Protestant, and Republicans, who are mainly Catholic, live separately. This divide is demonstrated through the two main political parties that we have here. The DUP are Unionist, and Sinn Féin are Republican. One of the reasons why I and a lot of people vote for the DUP is simply to ensure that Sinn Féin aren't the biggest party in Northern Ireland. Unfortunately, I have a feeling that a united Ireland is on the cards in my lifetime. If a united Ireland ever did happen, many people would feel very uncomfortable. Some would feel like they were living in a coldhouse for Unionists.

Nadine Davis
Hackney

Emergency accommodation is supposed to mean anything from a week to six months. But I ended up being there for over a year.

When I was 17 I decided I wanted to leave home. I'd been all over the place from around that time. I was at various hostels and at one point I was in assisted housing before I moved back in with family. That didn't work out, so once I was pregnant I was out in the world alone. I found that if I didn't have a stable home and I was moving around a lot, it made it hard for me to keep a job.

As a single mother I was fortunate to stay in my borough when I was moved to emergency accommodation. Some people get moved out, so I was lucky in that respect. My accommodation wasn't excellent. It was a hostel that I was grateful to have, but I was sharing a bathroom with strangers. I had just had a baby and sometimes you had people that were on drugs or people in relationships where there was domestic violence, which made the set-up difficult at times.

Emergency accommodation is supposed to mean anything from a week to six months. But I ended up being there for over a year. I think the council sometimes try to delay the process of moving you on because of the shortage of housing and the resulting backlog.

Eventually, in 2014 we moved to the place where we are now. At first, it was like 'wow', because I had a newborn baby and a new job, but both came with a lot of responsibility, plus the addition of a new flat that needed a lot of work. I was grateful but overwhelmed.

I appreciate my area. I feel that there's a real sense of community and it's very mixed, so my son gets to interact with different children. His school is only five minutes up the road from us and he has a diverse group of friends. It's nice for him to grow up in that environment.

At the same time there are a lot of changes that are happening around my area, which is daunting because people don't know what's going to happen. There was a recent issue with my estate where they want new buildings. They tried to move people out of their homes temporarily while they build new homes. This area is the last bit of Hackney that hasn't been heavily gentrified. And there's so much development happening around these little corners that you would think they couldn't fit anything more. And yet they're building these sky-high new builds.

Although gentrification has helped out in many ways, at the same time many people can't afford to have a life in Hackney. There are so many great things in Hackney, but the people that were born and raised here can't afford to do much of it. So they're pushed out because they can't afford to live or survive there.

I'm scared that London will end up a bit like Chicago, where you have the really rich and the very poor. Even though it's already like that here, I don't think it's as extreme yet. But it can get there. It's scary because I have a young African-Caribbean boy who I have so many hopes and dreams for. I don't want him growing up thinking he doesn't have a chance.

PHOTOGRAPHER: NICOLA MUIRHEAD

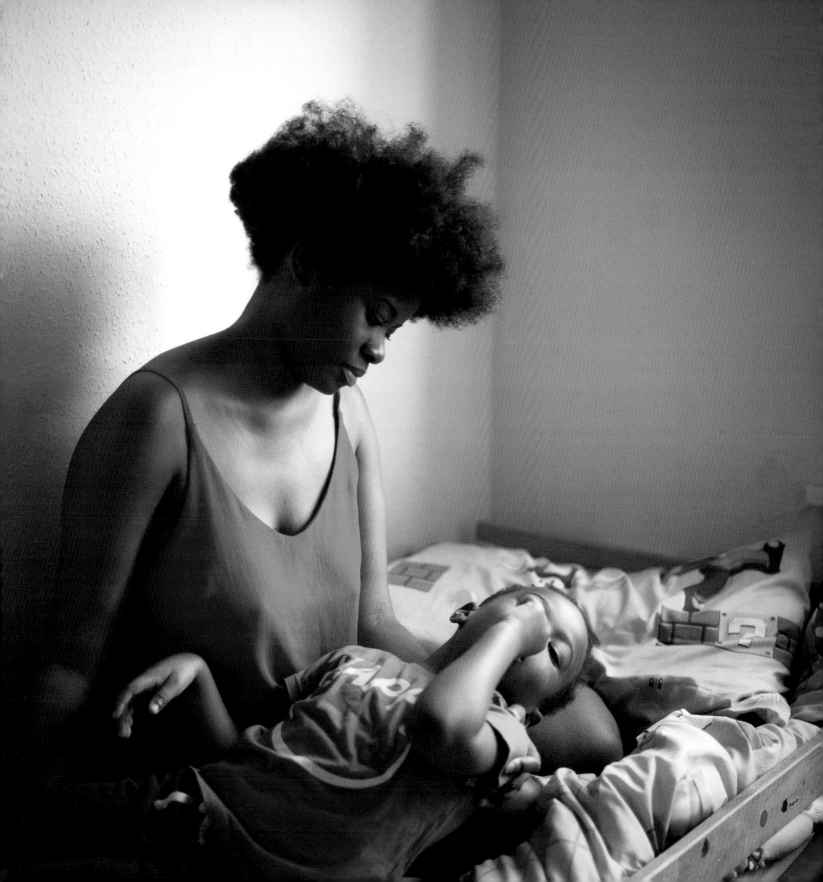

I think we are a great example that you
can start your life over again at any age.

MONIKA FARYNA-LUBECKA

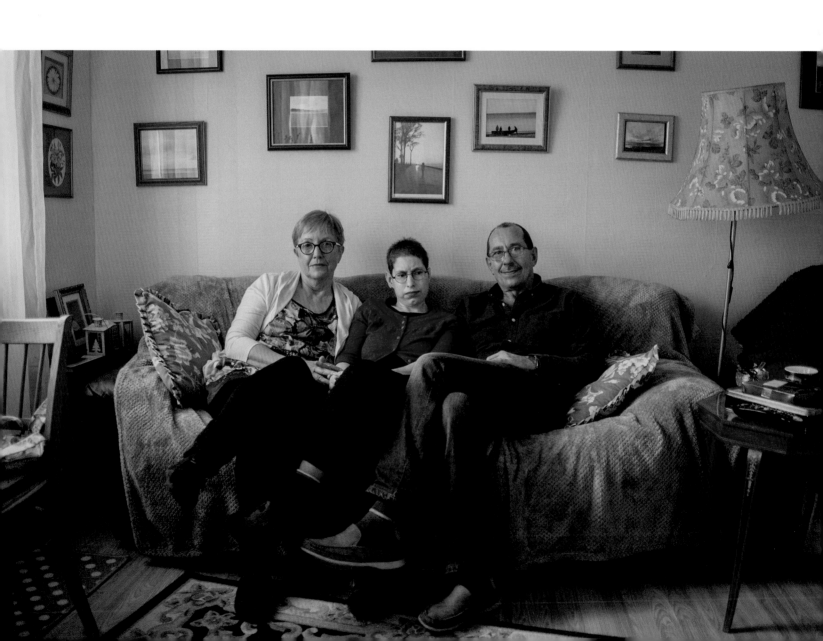

Monika Faryna-Lubecka
and Wieslaw Lubecki
Pilton, Edinburgh

Monika

Like my husband, I was born in Warsaw, Poland. We first came to Scotland when we were around 60 years old, in September 2013, and moved here for good in March 2014. Our daughter, Agata, who is 34 and has a disability, is also here. I have to admit that Scotland did a lot of good to us, to the whole family.

I cannot deny that my mind was split between staying in Poland with Agata, or coming here. But Agata made a choice for all of us; it was obvious for her that we should be together. And eventually we joined Wieslaw after a few months.

The beginnings were not easy, but I decided that since I'm here now, I wanted to feel as good as I can, for all of us to feel good about moving, and to treat it as an adventure. When I look at the last few years, I can say they have been the best, the happiest time in our lives – and I think we are a great example that you can start your life over again at any age. It made us feel both happier and younger.

Acceptance and tolerance are not empty words here. Being different here is OK, and in Agata's case we can really see this. I'm becoming a much calmer, mentally healthier person for it. And now I have time and energy to volunteer in local projects and be part of the multinational community here.

Pilton and neighbouring Muirhouse have traditionally carried bad reputations, but they are changing. They're supposed to be building a new shopping centre, so the place that had possibly the worst reputation in the town is going to go through a significant metamorphosis in the next couple of years.

I think that because we have decided to take this crazy step to move abroad at retirement age, we don't fear Brexit. We fear nothing now.

PHOTOGRAPHER: KAT DLUGOSZ

Wieslaw

Since my early childhood I was fascinated by Scotland. My grandfather came to Scotland with General Anders in 1947, after being with the Allied Army in Italy. My father used to be a famous tailor in Warsaw, making clothes for people from the worlds of art and politics.

In Poland I also had a clothing business. It was going really well, and for a year or so my dresses were being used in a TV music quiz show, and a dress that I designed and made was worn by the President's wife at a New Year's party.

Then everything changed and cheap clothes from China started flooding the market. It was like a big punch in a face. From day to day we had to sell everything and the business fell into ruin. I'm still working in my profession, though I'm not a businessman any more. Not much changed for me, but now I can live slower: I don't have to deal with employees, taxes, paperwork, thinking about money and how to pay everyone's wages.

Fate made me come here for my later years, and I feel so much happier now than before when I was a businessman, even during the best years of prosperity. I have never felt as respected as a human being as I do here. Even as an employee, I feel like someone. People treat me with respect, not as a thief wanting to cheat on taxes or anything like that.

After Brexit we initially felt this uncertainty; we weren't sure what decisions were going to be taken about us. But then it all calmed down, people started forgetting about it, and life goes on.

Susana Benavides
Finsbury Park

A supervisor was bullying me, and when I confronted him he told me women are only here for having children, and called me a donkey.

I was born in Ecuador in 1975. I've been in Britain for eight years now. For my first job in London I cleaned offices from 4am to 7am and then worked at a hotel from 8am until 10pm. I did that for three months before I managed to bring my daughter to London. I decided to find a job with less hours and found work at Topshop on Oxford Street. But I had problems with Britannia, the company contracted to clean the store. A supervisor was bullying me, and when I confronted him he told me women are only here for having children and called me a donkey. When I argued back he got enraged and kicked a bucket at me.

A colleague told me about a lawyer named Petros Elia from United Voices of the World (UVW), a trade union that represents migrant and precarious workers. I called him and for the first time I felt somebody was listening. I'd had bad experiences with other unions, who told me I would have to wait six months for them to take my case or that there wasn't anything more I could do. Petros told me something could be done. In that moment I realised yes, there is hope.

After being on sick leave for seven months due to depression, I returned to work. My old supervisor started to harass me again, but this time I wasn't alone; I was in the union. I told Petros what was going on and we sent them a letter. I met the owner of Britannia and his response was, 'Why did you have to go to a union? If you'd have called me I would have attended to what you were asking and needed.' I told him I had been trying to contact him for three years, had written letters through a GP advisor. But despite his promises, nothing was done to resolve my problems and the bullying continued.

I was depressed and didn't want to continue working at Topshop. I told Petros I wanted to quit and he said, 'If you're going to leave anyway, why don't we take advantage of that and just say everything that you want to say?' I decided I had nothing to lose.

We launched a campaign to demand fair pay and contracts for those working full-time, which Britannia claimed was not valid because 13 people had signed a letter stating they were happy with working conditions, even though they had signed in exchange for more working hours. At a private meeting the owner said, 'Susana, I don't want you to continue with any campaigns at my company, so tell me what you want and we'll give it to you. How much do you want? You've asked for a job Monday to Friday, you've got it. I'll make you a supervisor.' I told him the campaign is not called the Campaign for Susana Benavides. It's for all the workers of Britannia.

After that I went on holiday. When I came back I was immediately suspended. I started working at United Voices of the World. As well as legal advice, UVW also provides emotional and psychological support. We try to make all our members aware that this is not a service. We want to have them involved in the union and acknowledge that it's a community of people together – people who want justice, who want to organise each other to know our obligations and our rights, people who want to make themselves heard and who want to come out of the shadows.

PHOTOGRAPHER: GORDON ROLAND PEDEN

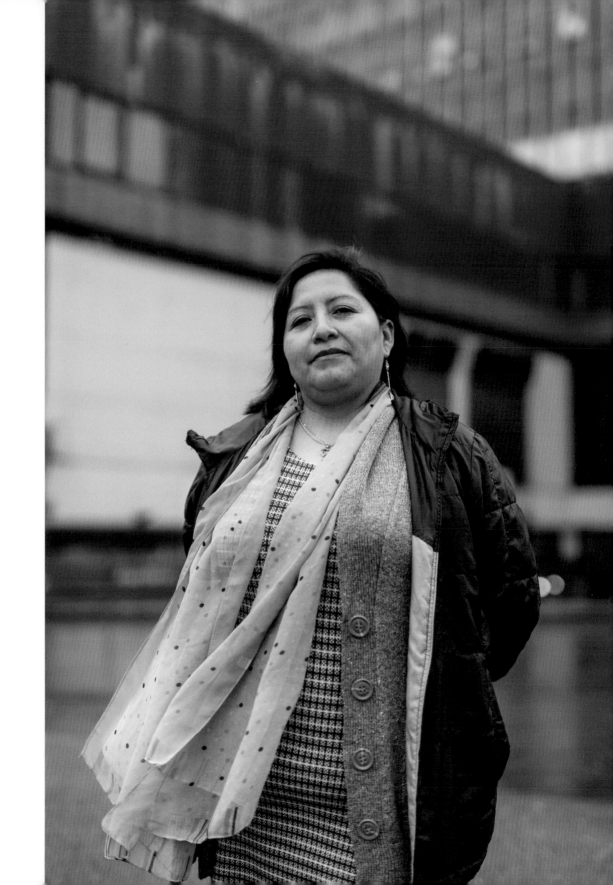

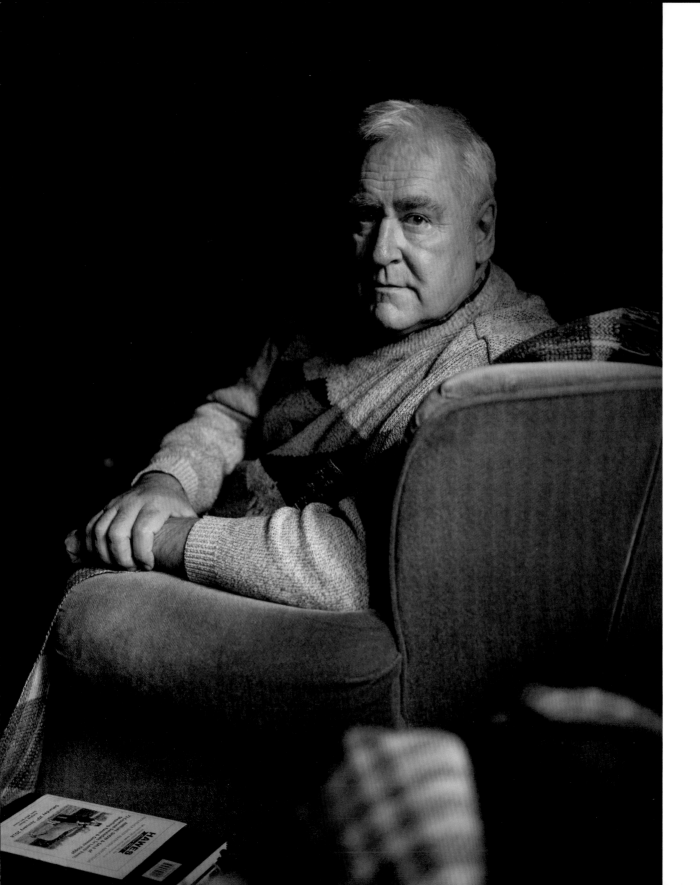

Will Cockbain
Cumbria

I think the EU got blamed for things it wasn't responsible for, not that it was perfect. Some farmers saw the referendum as an opportunity to have change.

I have farmed all my life. My family has been at this farm since 1937. Prior to that we were on a farm a mile down the road and we've farmed here in this area for over 300 years. So we're fairly indigenous – we're nearly locals now. At one time there were seven or eight farms in our valley and now there are only two, so that can bring problems. Similar to decline in industrial and mining towns, families and communities get spread to the four corners of the globe – or at least the country – and that causes social issues, because there isn't the family there to support like there used to be.

When you look at farming as an industry, I believe it has the highest or second highest suicide rate. The main cause of death for male farmers under 50 is suicide. Farming is quite isolating. I'm very lucky here, I've got quite a big farm and a brother and two sons. I knew a man who obviously had some problems that had been going undetected. He was a beef farmer and he lost his favourite cow – that tipped him over the edge and he committed suicide. That was hard.

Despite the decline in the number of farms and the remaining farms getting bigger, there is still public support for British farming and some respect for farmers. But I don't think that British farmers are as respected as farmers are in Europe. The French really value their farmers. Since 2005 British farmers no longer get any production subsidies; any farming support is all about managing the land and environment. Post-Brexit we just don't know how things will change. There's a lot of uncertainty.

I think that a lot of farmers perceived the amount of bureaucracy we have to deal with was down to the EU, but I think that a lot of issues were down to failed IT systems in the Department for Environment, Food and Rural Affairs and some of its own rules. I think the EU got blamed for things it wasn't responsible for. Not that it was perfect. Some farmers saw the referendum as an opportunity to have change – they previously felt their voices weren't being heard, but now there's an awful lot of uncertainty as to what the future will look like.

I wasn't sure how to vote. I was very much 50/50. I suppose I felt personally the best outcome would be to remain, but with significant reform. I really wrestled with it, there is an element of having that control over ourselves, but when you look deeper it's incredibly complicated. Forty per cent of British lamb goes to Europe, so without that market sheep farming could be in real trouble.

I don't think they've done a full impact assessment on the public support that goes into farming, as well as the income that farming generates in production activities. So much of that filters into the rural economies and I don't think that people are as aware of that as they could be. When farmers do make money they spend it, and they spend it in the local economy on other rural businesses such as local shops and local garages, machinery suppliers and local contractors. Farming money is sticky money – it gets reinvested in the area.

PHOTOGRAPHER: LAURA DICKEN

Raghad Haddad
Brighton

There were nine of us, all musicians. I was the only one who could speak English, not good, but better than the others, so I volunteered to speak about asylum.

I was born in Yabroud in Syria. In 2013 Jabhat al-Nusra – who are like Islamic State – came to my town and started to control it, creating an Eastern Court, Sharia Law. Other musicians were forbidden to work. The fighters would stand between houses shooting at planes and use people as human shields. There were many battles, many places bombed. They were there on the streets, in the city, controlling everything.

I'm a professional musician, a viola player. I used to work with the Syrian National Symphony Orchestra and taught at the Damascus Conservatoire. I was part of the Orchestra of Syrian Musicians and toured Europe with a company called Africa Express with Damon Albarn in 2016. After the tour I was supposed to go back to Syria, but many attacks happened there in the 15 days I was away, so myself and some friends decided to stay and claim asylum.

There were nine of us, all musicians. I was the only one who could speak English, not good, but better than the others, so I volunteered to speak about asylum. They didn't expect so many at once. After the interviews they handcuffed us to take us from the airport to a van, then to a detention centre close by. We were shocked; we were treated like criminals. I was strong, but one friend collapsed, crying. I told her to be strong. We'd just finished a 15-date tour being treated like professionals and staying in places like the Hilton. We were there for seven days. We had no luggage. They took everything, including my instrument.

I'd left my husband and my son, who was only three-and-a-half at the time. I had no way of contacting them. In our culture and for my husband, it wasn't acceptable for a mother to leave her child. After a year's separation my son was affected by it. It's still hard to communicate with him. He's angry. When I left, I didn't know I was going to leave him. He asked, 'Where's my Mum?' for a year. He needs to feel settled somewhere.

After the detention centre we were taken to hostels, some of us to Leeds, and some, including me, to Birmingham. Three people to a tiny room and the bathroom shared by everyone. There were many people from different backgrounds. We had nothing, no money, and they misplaced our luggage. All we had were the clothes we were wearing. I'd given all the orchestra money I'd made to a friend to take to my husband. By accident and kindness we eventually got our luggage back.

I miss my position as a musician in Syria, but mainly I miss my family, my mum and brothers. I've got no other family here. I'm worried and I miss them because my mum has only me and my two brothers. I'm not allowed to go back now. It's not a safe place to go back to. I need to see them because I didn't say goodbye to them. Every day when I talk to my mum, she blames me.

I got my papers in January 2017. After coming here I've had to build myself up from zero. I once had a good job and a good life in Syria. Here no one knows me as a musician. I hope to find a job, I hope my son grows up here in good circumstances and soon forgets what he came through. I'm happy now in terms of safety. I go out and I feel safe.

PHOTOGRAPHER: LISA WORMSLEY

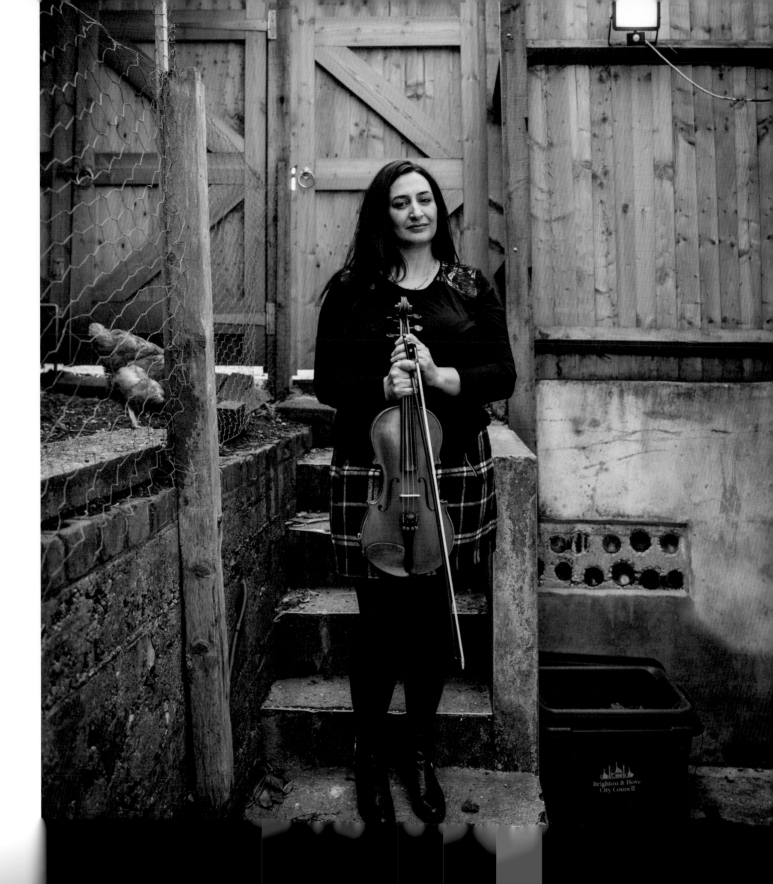

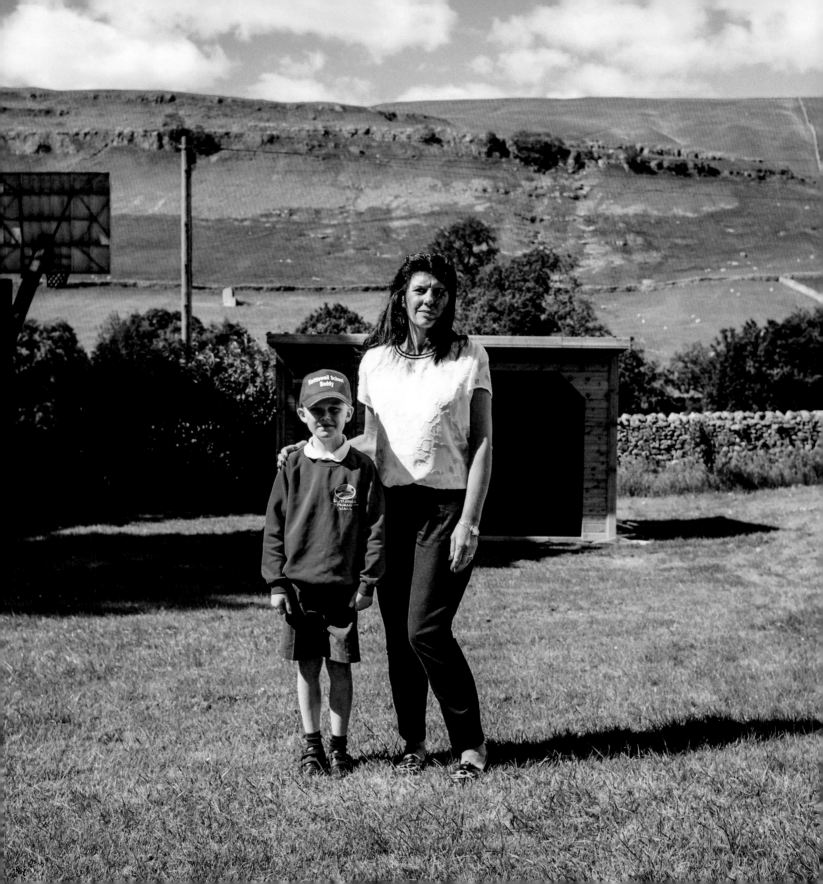

Tracey Briggs
Kettlewell

It always seems to come down to money nowadays. And actually, what should be more important is what children need.

I'm a school manager at Kettlewell Primary School, which is tucked away just outside the village of Kettlewell, a very small rural community in the heart of the Yorkshire Dales. It's full of fields and sheep and is very picturesque. We also teach children from outside the village from small hamlets up the Dale, which are very rural.

Property prices here are going up, which then restricts younger families moving into the area. This has an impact on the school, because if young families are unable to move here, then we don't have the new children coming through in the young years.

There's a new national funding formula that's come into play over the past couple of years, which has a massive impact on small rural schools. When they're talking about a small school, they're probably talking about a school of two or three hundred children. They don't get the concept of 30 pupils, which is the number we have. We're so vulnerable in that if a family moves out from the area and their children leave our school, it has an enormous impact on our budget, which is tight enough as it is.

It always seems to come down to money nowadays. And actually, what should be more important is what children need. They have one stab at primary school and it shouldn't be driven by money, but rather by giving those children the very best start in their education that they can possibly have. Sometimes we have to juggle things about in order to try and do that for them. And that's not always easy.

A small school like ours should be given a set amount of money every year, because that's what it needs to function and give those children what they should be entitled to in their primary education. It's such an important time of their lives. Primary school sets them up for their secondary school education and it should be the very best experience it can be.

Building these foundations when they come into Reception class and beyond is so important. But sometimes all the worries we've got regarding money can take us away from what's important, which is giving those kids the best that they can have. They should be allowed to have an education without the managers and the head teacher having to worry about just sustaining a school's existence.

I've been working in education for 22 years. And when I think back to when I started the job, I can already see it's unrecognisable to what it was then. We never knew what a risk assessment was. We'd never heard of asbestos, legionella, or all the health and safety issues that are now part of the role. Obviously, health and safety is very important, but the job now entails so much more paperwork than it used to.

Things are very different now to what they were when I started my first job as a school secretary. We're always on the back foot because of the finances, so we always have to look at ways of making savings. I don't like to think about where we're going to be in 20 years' time.

PHOTOGRAPHER: JOANNE COATES

Stuart Evans
Brackla

I've been in trouble quite a lot in my life. Nothing too serious, and somehow I've only been to prison once.

I was born in Barrow-in-Furness in Cumbria, but I've lived in Wales for most of my life now. I live in Brackla – or Brack LA as it's become known amongst locals – in Bridgend. It was once the fastest growing housing estate in Europe, and not much has changed here apart from the fact that the older people are dead and the young are taking over.

I've been in trouble quite a lot in my life. Nothing too serious, and somehow I've only been to prison once. That was at HMP Cardiff in 2014 on a battery charge. I was already on remand at the time, so I was going down whatever happened. I pleaded guilty for a lighter sentence. In the end, I got seven months and served three on account of good behaviour.

In prison we'd get woken up at 7.30am for roll call, then taken to the yard where we'd walk around in circles for 20 or 30 minutes. After that it would be breakfast, and then maybe watch some of the guys do rap battles with each other, which were great. After that we were locked back in our cells until lunch, and then it would be education time, where we would do all types of stuff that would apparently help with our rehabilitation.

Social time, or free time, was usually when there was trouble – mainly bullying, arguments, fights, etc. But the screws would usually have everything under control. Lots of stuff went on during social time and the screws are only human, so it was hard for them to keep an eye on everything. After that we would be locked up again, and this is when everyone was most restless. There would be lots of shouting, banging on doors and 'pipe code', which is how prisoners communicate with people in other cells, by banging on the pipes. Finally, at around 5.30pm it was dinner, and back to your cell for the evening.

Without a doubt, missing my family was the worst thing about serving time. And yet, it seemed to me like the prison service was doing a good job. I got on with most of the screws and they were nice enough to me. It all depends on how you behave towards them: if you don't respect them they won't respect you back, and they will make your time in there very difficult.

I started writing on my first night in there, as I thought it would help me get through my sentence, which it did. I just wrote about daily life in prison and stories of people I met in there. I wrote about the fights, rapes and suicides – and the funny things. There were three suicides while I was in there.

I've always needed to express myself through drawing, music, making things. So it felt quite natural for me to do something like this. It was self-medicating and I don't know how I would have coped without it. So far I haven't tried to find a publisher for the book, and I wouldn't really know where to begin. It would be nice to see it in the shops one day, though.

I really want to take my family and move to Greece. I go several times a year and I was out there recently on holiday. I just want a better quality of life for my family and also to be able to carry on playing my guitar and making art, which is something I've always done. It keeps me sane and out of trouble.

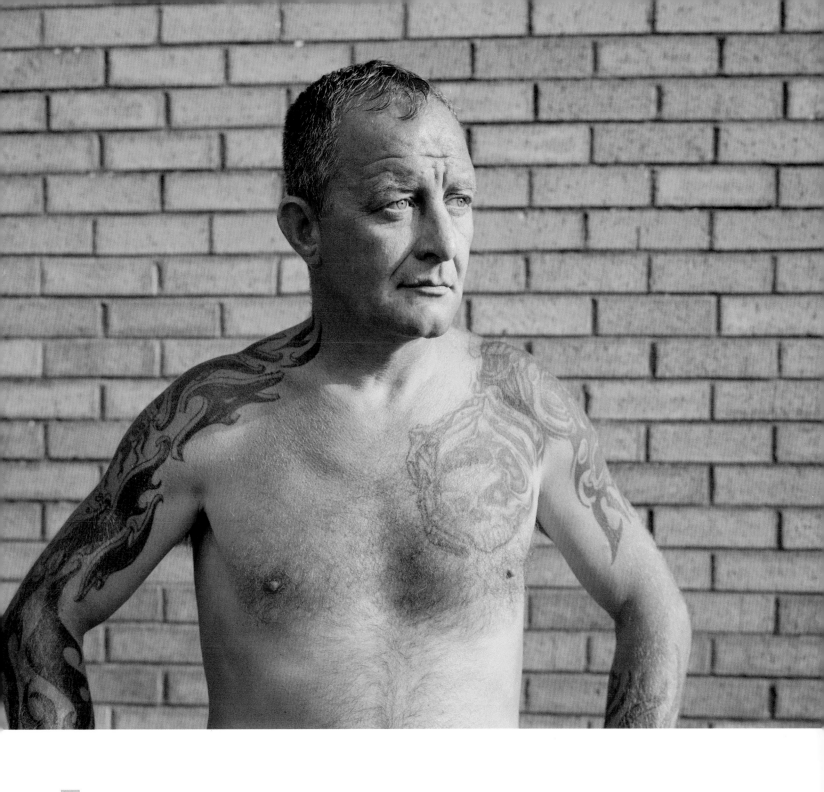

PHOTOGRAPHER: DAN WOOD

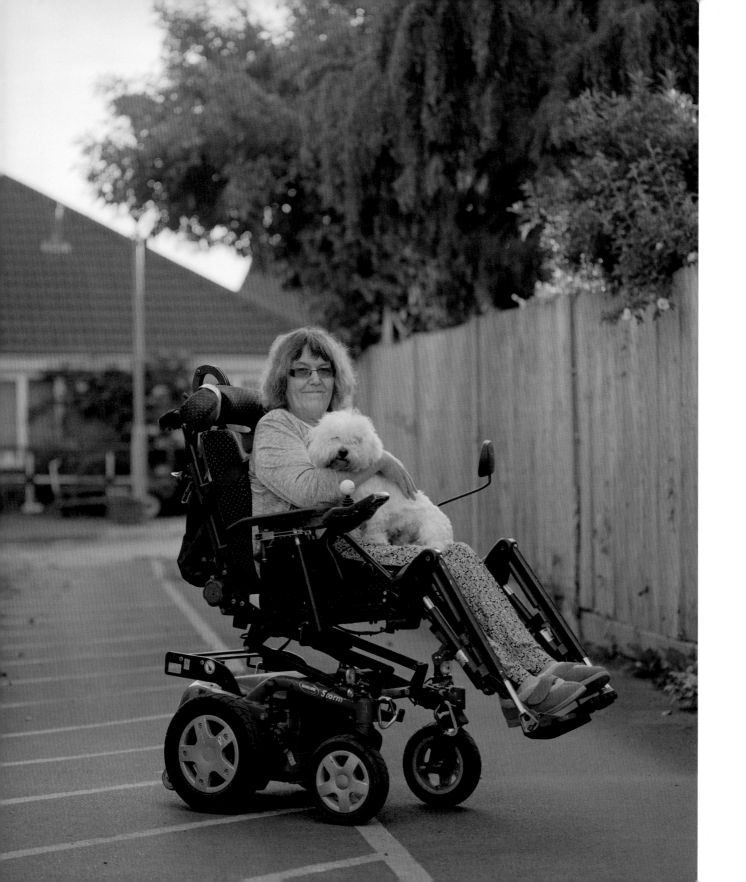

Karen Passmore
Bristol

We don't have to accept this attack on our living standards, we don't have to accept the demonisation of the various minorities, be they disabled, poor, single parents, immigrants or refugees.

I knew I was transgender from about the age of four, even though the word did not exist then. I knew I was a girl, even though I had a boy's body. There was no internet back then, no social media, no real medical knowledge. You couldn't talk about how you felt, tell others you were really a girl, when everything about you said the opposite.

I wasn't always an activist; it started when I became disabled. I saw the multiple cuts being made to disability benefits, the harm that these were causing, the deaths and suicides and the despair that so many were experiencing.

I was invited to be a speaker at a mass rally against austerity in Bristol. It's quite scary if you have never spoken in public before, but I got through it okay and my speech was generally well received. I started a new branch of DPAC, Disabled People Against Cuts, as I felt it was time we did something to make our voices finally heard.

Since then life has never been the same. Our DPAC Bristol & South West branch has grown via social media, and we now have a real voice and a presence. I've been invited to speak at rallies and demonstrations all over the country, from an action to unseat the former Minister for Work and Pensions, Stephen Crabb, to supporting demos against NHS closures, and a panel to discuss the impact of austerity on social work.

Recently we held a demonstration in Bristol to highlight the introduction of Universal Credit and explain to people exactly what this means. We got soaked, but what does a little rain matter when you are an activist?

Little by little we are hopefully changing minds and opinions, and countering some of the lies spread by certain sections of the media. We are telling people there is a better way, that life doesn't have to be as hard as it is today, that austerity is a deliberate ideological choice designed to punish the poor for the deliberate actions of the rich, particularly the bankers.

We don't have to accept this attack on our living standards, we don't have to accept the demonisation of the various minorities, be they disabled, poor, single parents, immigrants or refugees. We can stand up, join forces, and support one another. We are one.

Being an activist is not being a troublemaker, as some will claim. It's not being a hippy or just a noisy protester. It's about caring, for your family, for your friends and neighbours, and even for those you may not know yet. It's about having a voice and using it. Who wants fracking on their doorstep, or local schools or services shut down? Who wants to see the elderly confined to one room trying to stay warm in winter, or kids going to school hungry or people starving the world over?

For me, Eve Ensler sums up perfectly what it means to be an activist, as someone who 'is not usually motivated by a need for power or money or fame, but in fact is driven slightly mad by some injustice, some cruelty, some unfairness, so much so that he or she is compelled by some internal moral engine to act to make it better.'

PHOTOGRAPHER: JON TONKS

Zhenya Blonsky
London

I try and bring a sense of love, belonging and family to the women. I believe in every one of them and I will never stop.

I'm an activist and outreach worker for women in street-based prostitution. At night I patrol the streets with a volunteer giving out condoms, drinks, snacks, panic alarms and advice about keeping safe, including giving out alerts about violent punters. Most of the women know me and come to the car to have some safe company and a chat. None of the women want to be street-working. All of the women I encounter are there to fund their own and often a boyfriend's addiction.

During the day I support the women around issues such as health, housing, experiences of violence, access to drug and alcohol services, and benefits. My work varies to match the needs of the women, whether that's in court or in a café.

Growing up, I lived in a flat above a street where sex workers picked up their clients. I saw the women every day getting in and out of cars, looking so tired and sad. I don't remember as a child feeling much. I was just very curious about what they were doing and how unsafe it all looked.

I'm not looking down from above any more. Now I know the women and it's these personal relationships that drive my commitment and passion. I'm also motivated by the injustice I witness daily. Everything is more difficult – the drug and alcohol services we work closely with have had a 40% cut in resources in recent years. A few years ago you could ring up a detox centre and be admitted within days. Now the women have to wait months to get into detox or rehab. Most of the women give up.

Sometimes I feel how I imagine the women must feel, as I battle with authorities for their basic rights. They treat me like they treat the women; they just wish I'd go away and stop being a nuisance. Some women aren't known to any services. No one cares about them. They are invisible. They have slipped through the gap. And the gap is increasingly wide these days. Many have run away from care or have been introduced by a boyfriend to drugs and prostitution. It's dark and complicated. There is so much historical trauma and then this ongoing abuse. It's hard to know where to even start.

I feel like most of the women were set up. They never stood a chance. Many didn't have anyone to love them as they were growing up and have only ever experienced abuse. I try and bring a sense of love, belonging and family to the women. I believe in every one of them and I will never stop. No matter how many relapses someone has, I think you have to keep going and believe that change is possible. I've watched women get drug-free to keep their baby, exit prostitution, leave abusive relationships, go through rehab. It can happen and it's very satisfying when you see change. What gets me through each day is seeing the smaller but just as significant changes.

Recently the charity I worked for lost its funding and we closed. Around me all the services are being reduced, but the demand is greater than ever. This just reinforces the beliefs that the women have of themselves – that they are just 'prostitutes', nobody cares about them and they are not worth investing in. I'm now trying to set up an organisation that will enable me to continue my work.

PHOTOGRAPHER: FIONA YARON-FIELD

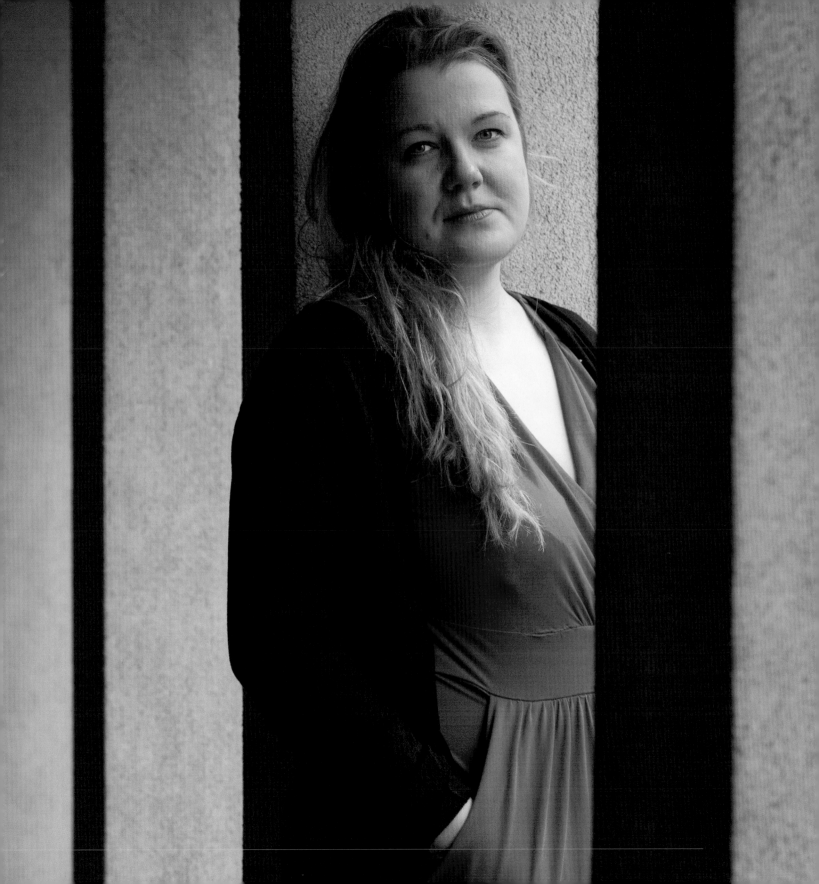

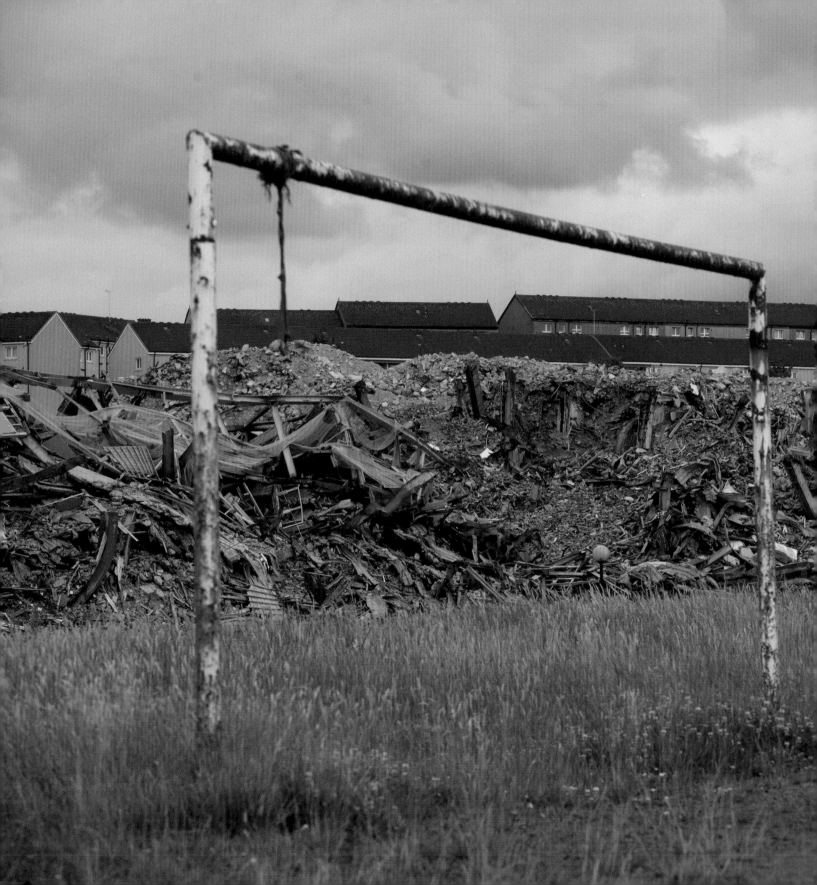

PHOTOGRAPHER: ROBERT CLAYTON

Stewart Baxter
Hull

I'm passionate about young people knowing that everything is political.

I work within The Warren, a youth centre and charity in Hull. I've seen the effects of austerity on the youth and community support services here, to the point where we almost closed recently. Thousands of young people would've had nowhere to go if we'd shut the doors.

I've seen the young people we work with and how they survive, whether that's through benefits or through getting a job from being in college, and how things have been cut and pressures have been put on them so they can't afford to do certain things. That means they've got to drop out of college and then they're in an even worse situation. I'm seeing people's lives go downhill. I'm seeing people in situations where they're committing suicide or attempting to because they see it as their best option.

I've managed to stay in my job. I've managed to pay my rent, to feed myself and stay reasonably on a level where I'm not struggling through poverty. I feel very lucky to have got through that, but at any point I could have lost my job. At any point I could be on the streets. I don't ever take that for granted. To go through life thinking that at any point I could be on the streets or unable to afford to buy my tea is just horrible. It's dehumanising and that's what austerity does; it dehumanises people. While others get richer, other people die or take their own lives.

I'm passionate about young people knowing that everything is political. The price of your baccy, the price of your rent, how many bedrooms you've got and are allowed to have, it's political.

I think it's really important for people to vote and to get involved in politics. Social media can be a really evil place, but actually through instant news you can also make a change very quickly. I think that's really inspiring for a young person to see that.

Where I work I see creative and socially active young people getting really pro-active, campaigning against things they don't believe in. There's a logo, there's a campaign and they're like, 'We're going to do something about it'. And it's with no money, just passion. The government don't realise that the inventors, creatives and young people are the future of this country. They should be tapping into them to be the future of the parties, because they're coming up with amazing ideas that are going to blow our minds. They're digitally and creatively ahead of everyone. The sad thing is that if people don't understand that, then they get pushed out of that conversation and that's the biggest problem.

Despite what I've seen of austerity, it's important to say that there's an absolute beauty in how people look after each other and are there for each other. On a very basic human level you can't kill that community. And that gives me hope, it makes me smile. It keeps me optimistic. You'll never get rid of that, no matter what you do. I've still got that heart and soul.

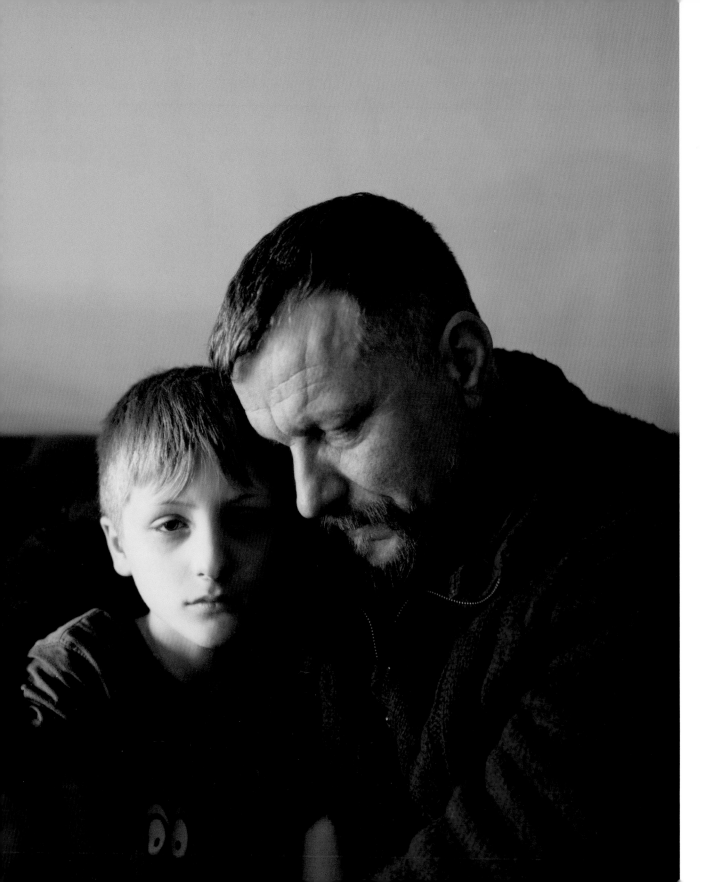

Ian King
Nuneaton

I just couldn't move. I was on that many different opiates, my body couldn't cope with it.

I studied Fine Art at university and graduated in 1989. My working life since has been quite varied. I've been a labourer, a cleaner, and spent time fabricating art works. I've taught life drawing and worked on tarmac gangs. I've driven a lorry delivering steel, and lately I've been tattooing. A lot of what I've done has been hard, heavy, physical work, and over the years that takes its toll.

I think I did too much. It was after I'd been tattooing for a while that it sort of caught up with me. I started getting cramps in my hands. My neck was starting to hurt, my back was hurting, but you take painkillers and try to work round it. I went to the doctor and I think he thought I was some sort of hypochondriac. I went for an MRI scan and they found out that the discs in my upper back had started to disintegrate and there were problems with my spinal cord.

I'd been taking paracetamol for the pain, but as it worsened, the medication I was prescribed became stronger and stronger. Paracetamol became diclofenac, and then I was on Solpadol. After that, pure codeine and then it went on to tramadol, diazepam, amitriptyline, all of this at the same time. In the end I was taking eight Solpadol a day. Each one of those contains 30mg of codeine and 500mg of paracetamol. I was prescribed tramadol, but I was still taking 400mg of codeine every day and all the other stuff too, because the pain had returned. I was still working at this point, tattooing during the day and fitting doors in supermarkets at night. Eventually, things came to a head and I started seizing up. I just couldn't move. I was on that many different opiates, my body couldn't cope with it.

I reached a point where I just couldn't take it any more. I was in a state. I just had to wean myself off all of it. I went into a very difficult period of withdrawal, all of the classic symptoms: scratching, muscle spasms. It took about seven months until I felt that all the stuff had left my system. When it had gone, I found that the pain that remained I could just about deal with.

I managed to get a driving job delivering car parts. I drive about 5,500-6,000 miles a month around the East Midlands. It's minimum wage work, which presents a new set of problems to deal with. I get by on the bare minimum. I'm being paid monthly for the first time in my life, and the last seven days up to payday are the most difficult. I'm scraping by to live, to feed myself. You get into borrowing money, which means I get further and further behind. What savings I had have dwindled to nothing and I'm in a routine of just trying to make ends meet each month.

I've got two kids, my daughter Annie, who's 15, and Finn, who's 10. I feel frustrated that I can't afford to support their educational needs. It's a big worry and I try not to think about it, but it's going to catch up with me in the end. I just hope that through their education they can find a way through. I just want them to be happy, really.

—

PHOTOGRAPHER: JOHN SPINKS

Jenny Carter
West Cornwall

The biggest thing for me about being a single parent is the fact that people do seem to think that it defines you in some way.

We didn't have a lot of money growing up when I was a child. My mum was on her own from when I was quite a young age, so I got used to that and know how to spend accordingly. It's been more difficult recently because I've been trying to do some voluntary work to try and get better job prospects, but that means paying for my daughter to go to nursery and that's where it's really hit me. I've just taken her out of there until she gets a free funded place.

I feel like there is a huge cloud of doubt over this country. The current government has made a lot of big changes, which affect all sorts of people, but in my opinion it's the lack of information about these changes that has been the biggest problem. Brexit is the best example of this; even now none of us knows what will really happen when it all goes through.

Another one is the changes to the benefit system with Universal Credit. We all know it's happening, but not when it will happen to us, and I haven't been given much information at all on what it even is. All they are telling us is that we should be prepared to wait a length of time for payments and that we should have money put aside for this. I don't know anyone in my financial situation who would be able to do this. Making changes is one thing, but keeping people in the dark about what's happening to their own country and their own lives is unfair and shouldn't be necessary.

As a single parent to my daughter from before she was even born, the biggest effect on me has been budget cuts to the NHS and family services. This was noticeable when she was born 18 months ago, but has become even worse now, with support being aimed mainly at parents who are in dire need. They should of course get that support, but it needs to be offered to everyone to prevent it getting that bad in the first place. Even locally, free or inexpensive groups for parents and children are being closed down, taking away a vital service for those who are vulnerable to isolation and in need of a point of contact for support, especially in the early days of becoming a parent.

The biggest thing for me about being a single parent is the fact that people do seem to think that it defines you in some way. I was at a Christmas do with a friend last year and someone said to me, 'Oh, so what do you do?' Before I had a chance to answer, someone else I knew at the table just said, 'Oh, she's a single mum.' And I felt like saying, 'That's not my job, that's not who I am. That's just my situation.'

I enjoy the fact that I make the decisions; we do whatever we want to do. There are some families who have both parents, and because they can't agree on anything, they're arguing all the time. And that's probably even harder than being alone and actually just being able to make the decisions yourself. So in that sense I quite like it. I don't have to clean anyone else's clothes or make dinner for anyone else.

PHOTOGRAPHER: AMARA ENO

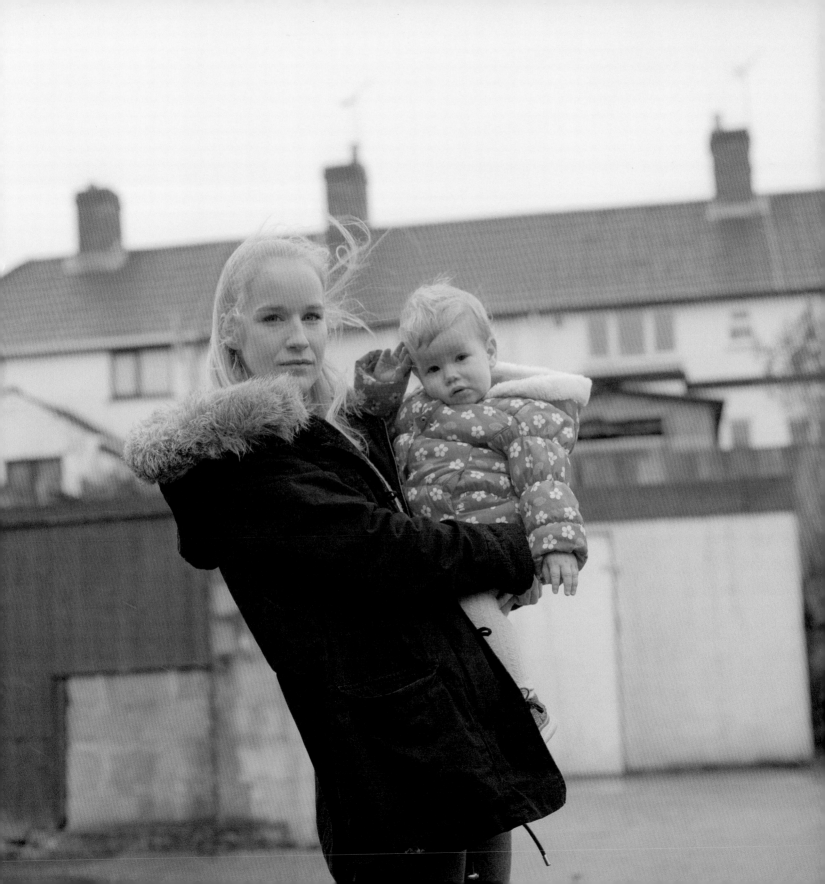

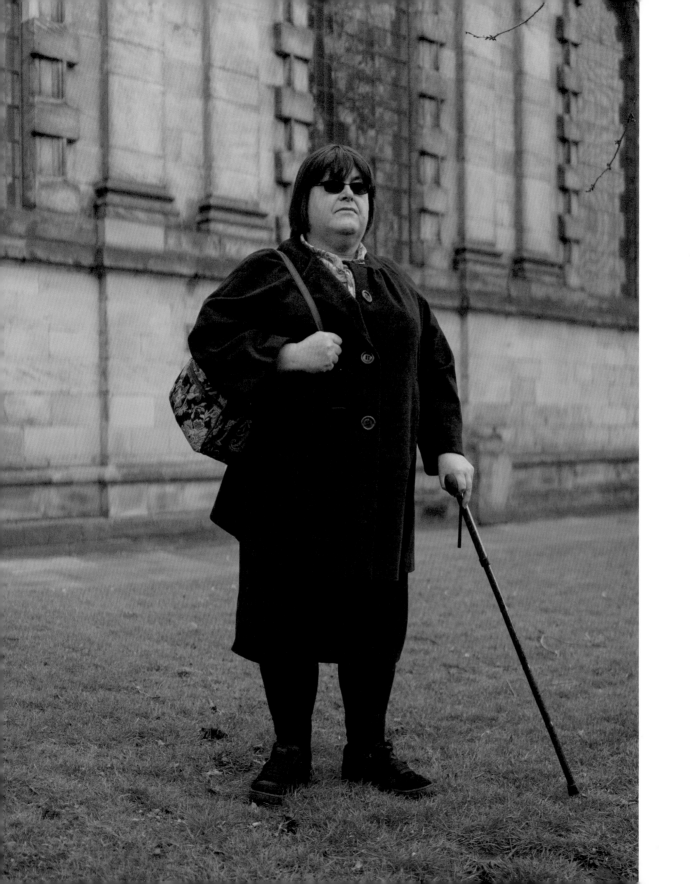

Georgina May Ford
Derby

Being a trans woman in the 70s was exceedingly difficult. We weren't breaking Queen's Regulations by being transgendered, but the military police thought that it could be used against us.

I was born in Derby in 1956. The house I was born in was one of a long row of terraced houses on Bloomfield Street. On one end was the Osmaston Road, and at the other end of the street was where they built the London Road Community Hospital. It was fairly downtrodden, and a bit grotty, but it was my home. You could live in worse places.

I joined the RAF in April of 1976 and went into basic training at RAF Swinderby for six weeks, before I was posted for my trade training at RAF Locking in Weston-super-Mare. My first posting was working in various jobs at RAF Henlow, where I began in construction, in a factory making things. I didn't necessarily know what they were, but that didn't matter. We just made things according to a set of instructions.

Eventually I got fed up with that and moved on to a public address flight, which took me all over the country to the various air shows. We used to put up all the tannoys, speakers and equipment for the general public. It wasn't unknown for television and sound crews to sometimes use some of our sound gear.

After a few years and lots more training, I ended up in Berlin for three years during the Cold War, working as an electronics technician. I'll never forget certain things and certain people. I met some people that I'd be happy to see again and have a pint and a chat with. But I've also met some people I'd never want to see again.

Britain today is a very different place to when I was a kid. The advent of electronic technology such as computers all started in the 60s, which is more or less when I started becoming interested in the subject. If I was to go back to the 60s now, it would be like going back to a different planet altogether. The television has changed so much, radios have totally changed. And society has changed with them.

Being a trans woman in the 70s was exceedingly difficult. We weren't breaking Queen's Regulations by being transgendered, but the military police thought that it could be used against us – that it could open us up to blackmail. So a lot of people who were transvestites or transgendered were effectively pushed out of the military. You had to be damn careful.

Nowadays, the situation has changed with attitudes to diversity being what they are. The RAF is much more aware of a need to accommodate different genders, and it's no longer seen as being a bad thing. Now I can walk around town and just be totally ignored and that's great. No one is taking the mickey out of me, or throwing stones at me. Society as a whole is more accepting than people think.

Today I work in a charity that helps to support LGBTQ communities, and we've been very badly affected by austerity. We lost all our funding from the local authority and we were in a precarious situation for some time. We've had to cut down certain services, but people understand and they know what's what.

If I have one hope for the future, it would only be that people stop bickering and squabbling with each other, and stop threatening each other with nuclear bombs. If we can stop these idiots accumulating the type of weapons they're talking about, then I think we'll be a bit safer.

PHOTOGRAPHER: CARL BULL

Demelza Toy Toy
World's End

Am I accepted because I'm the token black woman to make up a percentage of black artists, or for my hard work and talent?

The World's End estate is pretty much out of sight from the private residents in Chelsea. The estate hasn't changed much; we still have our built-in community, the church, theatre, corner shops, people struggling to survive in an area that has expensive bars, restaurants, retailers and groceries. The area around us is constantly being bought up and developed by corporates, turning it into private land. Business rates have gone up so much. People think of Chelsea as a rich area; actually, it has become an enclave for the super-rich.

Years ago, all the punk bands and rock 'n' roll stars lived around here. It was such a cultural area that embraced style, fashion and a community of misfits and artists. People could be on the dole and continue a career as an artist. You could rent cheap spaces to rehearse, create art or live and be at the heart of something great.

I have no support with my rent. I don't claim from the job centre, as they don't understand my choice of work or the way I choose to live. Being an artist is not a career; I have to find other ways to support myself. Working full time in a system that uses your time to make profit for others is not efficient for making art or for society in general. Corporate thinking has hijacked everything. Thirty years ago signing on and claiming the dole was how many artists were able to support their work. That system doesn't exist any more, meaning that art truly is an activity for those with the privilege to make it.

Poor people need to make art too. So I have use to use my initiative, live a very simple lifestyle, depend on the generosity of friends and family and collaborating with artists and musicians. I guess the real difference between now and then is that everything is so much more precarious. Zero contract hours, no protection for long-term tenants. Guaranteed debt in return for educating yourself. None of it makes any logical sense for society.

I still question myself as a struggling black artist. Am I accepted because I'm the token black woman to make up a percentage of black artists, or for my hard work and talent? As a black person, I have more chance of building a castle out of butter in the Sahara than being a woman of colour making art in a contemporary art world run by white males that enforces a neoliberal agenda, a way for super-rich people to make more money to reinforce their wealth.

Britain hasn't evolved; the education is white, the knowledge is white, the news is white, the artists are white, the politics is white. As a kid the racism was transparent; I knew who was a racist. Today it's disguised by our institutions. People say they aren't racist, but behavioural patterns and lack of equal access can make us feel excluded. How we are portrayed in the media, stereotypes and structures all need to be broken.

My hope is that the younger generations are smart enough to undo or challenge what we have done. I see these talented black women doing amazing art, amazing creative work, who refuse to be part of the system, but why are they struggling? Then I look in the other direction and see mediocre white people doing mediocre art and getting ahead. That's Britain today.

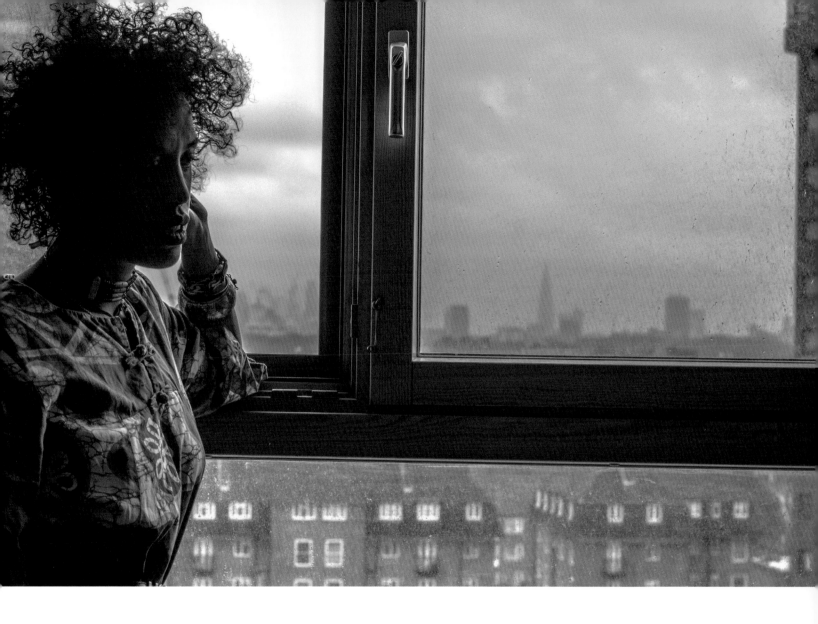

PHOTOGRAPHER: CINDY SASHA

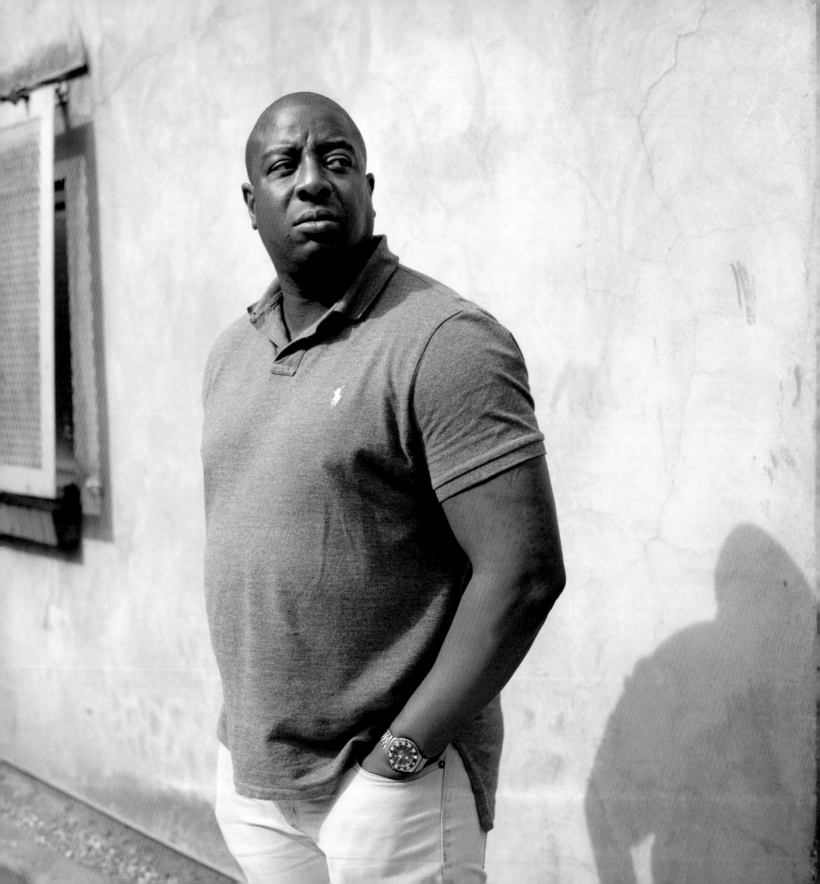

Errol Cole
Birmingham

When I was selling drugs I was always thinking about the money. I didn't actually see the effect it has on the users.

My lowest moment was going to prison for the first time when I was 18. I got 30 months for robbery. I didn't target kids or anything like that. I was targeting rich people. Looking out for who's got a Rolex or a pinkie ring. It wasn't desperation. I just wanted more money.

I was born and raised in Brixton, in Angell Town. We had drug dealers in our area and we looked up to them as father figures. They would look after us. It wasn't necessarily grooming. It was 'Here's £100 of coins – change up £70 and keep the rest'. When I turned 15 I thought, 'This looks easy. I'm sure I can do this as well.' I decided to buy my own drugs and build my own line. I was making between three and four grand a day. It was great. I'm not gonna lie. Anyone that says they didn't enjoy the lifestyle is chatting rubbish.

Back then you weren't peer-pressured to go into a gang. You could walk anywhere and wouldn't get into trouble. Nowadays, if I'm wearing a tracksuit and I go somewhere, a lot of young kids look at me like they wanna have a fight. It's different now compared to back in the day. The kids are more forward and will get into selling drugs, they'll be in gangs, but I think most of them don't actually want to go to prison. They'd rather stay in school, go to college, university, and get a job. Most of the violent crimes – the shootings and stabbings – are being committed by kids that are under 21.

A lot more kids are getting peer pressured into joining gangs. People join for protection. Some gangs form a type of bond where you're like a little family unit. They always say you're stronger in numbers. But if you're not in a gang, and you're just by yourself and doing the right thing, you're strong anyway.

I've been to prison three times for three sentences. But I don't think it actually hit home the first time, 'cause you're thinking, 'I've got this amount of years for these drugs – I'm gonna come out and do the same again, 'cause I need that fast money.' But you can't sell drugs for the rest of your life. There's always going to be consequences. Either someone's gonna try to rob you, you're gonna get set up, or the police are gonna come and get you and you'll get a very long time in prison.

Prison is what you make it. If you want to further your education in prison, you do that. There's a lot of help. If you don't want to do that, you're just gonna sit in your cell and procrastinate. I put myself through a lot of courses. Drug courses, to get that view on how the service user was feeling. When I was selling drugs I was always thinking about the money. I didn't actually see the effect it has on the users.

I've been a qualified chef for 15 years. Getting used to the minimum wage was really hard. When I saw my payslip I thought, 'Is that what they're giving me? I could earn this within an hour.' I was so used to a party lifestyle. I had a car, bike, jewellery, loads of girls. But you get a lot of fake friends that are around when the money's there. Once the money's finished, they're nowhere to seen.

I now work for a charity called User Voice, which is based alongside probation to give ex-offenders a chance within the criminal justice system. There's a lot of us out there with lived experience. We're the right people for these kinds of jobs because we can actually relate to the service users. They've been homeless; I've been homeless as well. I've drunk alcohol and taken and sold drugs. I've been in a gang. I can talk to them.

I just want to help people and be a positive role model. If I help one person, I know I've done my job. From one you go to two, then to three and four, and so on. I feel very positive.

Craig Dodds
Peckham

I love Brexit: I voted for it. My whole family voted for it. I was quite surprised, given they're Scottish. People say, 'Oh, but the EU funds this and funds that', but where exactly do they think the EU gets the money to fund these things? It's our money. If you give me £20 and I give you a tenner back, would you thank me?

My main reason for voting to leave was sovereignty – all these unelected politicians in Brussels need to bog off. You notice lots of failed and disgraced politicians seem to end up working for them. I think there's no such thing as 'soft Brexit'; there's only Brexit or 'hard Brexit'. Anything else is a con job. Same with this nonsense about having a second referendum – another con job.

Some people even say we might need a third referendum. What they really mean is we should keep voting until they get the answer they want. And of course they want to lower the age of voting as younger people are more likely to vote to remain. Well, they would be after they've been through our brainwashing education system.

I'd like to see us withdraw immediately. I don't care about any deal they're trying to hash out. To be honest, I very much doubt we will get a good deal anyway. Our so-called friends and partners in the EU certainly want to punish us for leaving. With friends like that, who needs enemies? I think there'll be some pain economically, but that should sort itself out and eventually we'll be a happier nation.

I'd been disillusioned with the EU for a good decade by the time of the referendum. I'd always told people they'd never give us a vote on our membership, as the British public would vote to leave. And when you think of how the establishment all came out in favour of remaining – the leaders from the three main political parties, the BBC, almost every newspaper – I think it's astounding that Leave still won.

Living in London, I've experienced a lot of backlash for how I voted, but ultimately it's my vote and I'll use it how I want. Lots of the Remainers seem to think they have a moral superiority to you if you voted Leave. The worst was when I was called a racist in my own house. Apparently the French and Italians *et al.* are now a different race, which is news to me. The whole thing is so ridiculous, but I do understand it's an emotional response from people unhappy with the outcome.

I fully expect there to be another World War. On the plus side, it might actually unite us again as a nation if we were up against a common enemy. Everyone's so divided nowadays – you see it all the time on social media, people deleting old friends or family members 'cause they don't like how they vote. People living in echo chambers. How boring to have everyone agree with you, and how egotistical. To be honest, it's probably time for the reset button to be pushed on humanity as a whole anyway. I'm an animal lover and I say give the Earth back to them.

PHOTOGRAPHER: POEM BAKER

*Some people even
say we might need
a third referendum.
What they really
mean is we should
keep voting until
they get the answer
they want.*

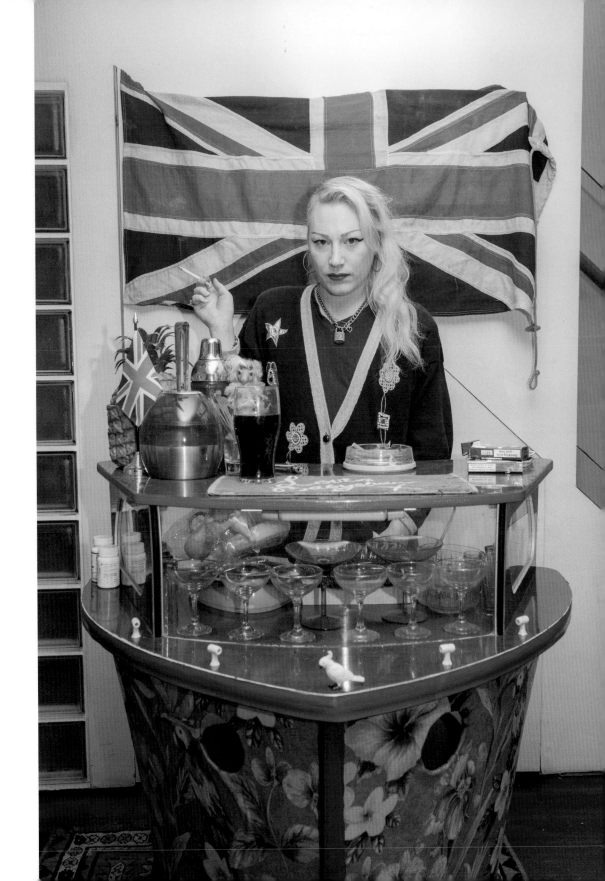

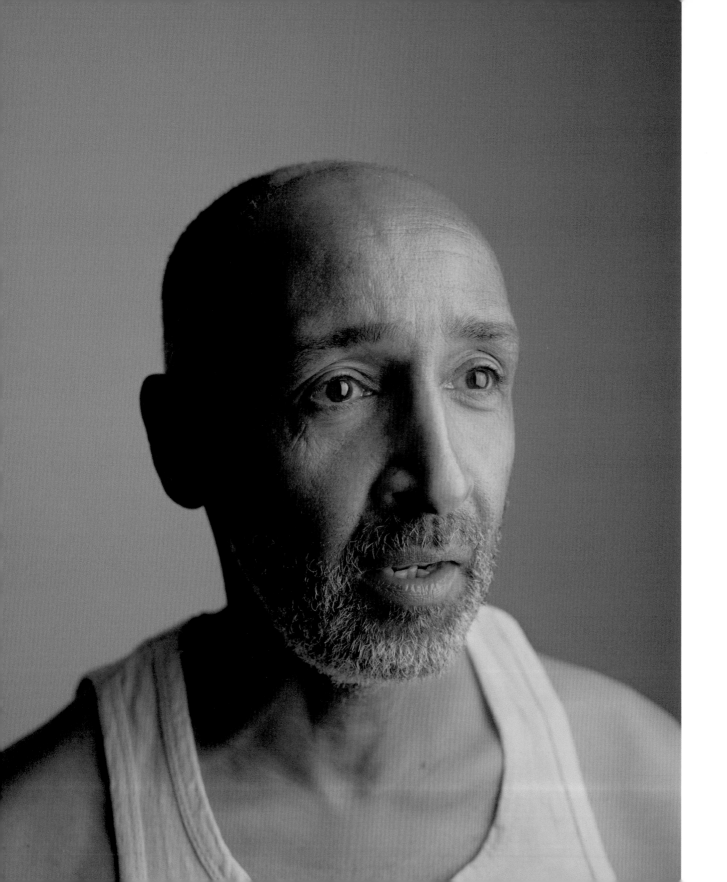

Carl Phillips
Carrington

We need to look more widely at the contribution that black people have historically made to British society.

I was a miner at Bevercotes pit in Nottinghamshire from 1980-1992. I started off as a haulage lad and would go on to work in all areas of the mine. After the 1984 strike, which I worked through mostly because I was a member of the Union of Democratic Mineworkers (UDM), I got a job as a deputy.

Working in a coal mine was like nothing else I've ever done. It was extreme: we were 2,000 feet underground and it was hot and dusty. Putting your hand in front of your face and not being able to see it was a strange experience. Absolute darkness.

My perception of racism changed when I was in the pit. It wasn't that the racism disappeared with this sense of camaraderie. I was just more tolerant of the sort of things that would happen. The idea that it didn't matter where you were from, you were all in the same situation and therefore these distinctions disappeared… they didn't. In some ways the extreme environment masked racist attitudes.

I was more tolerant of it once I was underground. I felt it more when I came out of the pit and there were all sorts of things that happened that were overtly racist. For example, at the end of a shift in the pithead showers, miners always washed each other's backs – often there were white miners who wouldn't wash a black miner's back.

Interacting with fellow miners was harsh and direct. And often quite brutal. You were called 'boy' and all kinds of weird stuff went on. Because you were black, you'd be given some of the worst jobs. There was something about Bevercotes that was slightly different to what I would call the traditional pits like Ollerton and Annesley, which had been open for years. Bevercotes had only been open since 1960, and, unusually, there were three black and minority ethnic deputies.

The traditional portrayal of miners as noble workers toiling for the country in terrible conditions has an essentially white British feel to it. Other heritages working in the mining industry were simply not given recognition because it didn't fit into this framework of Britishness. Many people from the Caribbean who came over in the 50s didn't want to rock the boat too much, and had this attitude of 'Let's just stay below the radar in case something nasty happens to us'. As a result, they're perhaps viewed as easy targets, as low-hanging fruit. With the Windrush scandal, this has come to light. Otherwise people might not have spoken out.

I've spoken to former miners who are now in their 70s and 80s who came across from the Caribbean, and they've told me 'We actually worked in these conditions and now they're telling us that we're not British'. We worked in a really extreme industry, putting lives on the line, and it's outrageous to not have that recognised, and for people to be not given a sense of belonging and a recognition of what they've done for where we are now as a society.

The black presence in Britain has been filtered out. We know people came from the Caribbean and helped rebuild this country in the post-war era. But we don't examine the details of that. We know that there were people who worked for London Transport who came from the Caribbean. We know there were many people who worked for the GPO who came from the Caribbean. But there's more than that; there are black people that worked in the mines, in construction, in every industry. And for some reason, that's beyond the filter. We're not paying attention to that. We need to look more widely at the contribution that black people have historically made to British society.

PHOTOGRAPHER: DAVID SEVERN

Aysha Iqbal
Smethwick

The word 'Islamophobia' was something I learnt sometime after 9/11. Until then, I didn't know what it was. I didn't know that it was called Islamophobia until it formed into this thing that had a name.

I was born and bred in Birmingham, where I grew up with my mother, Zatoon. My mother came over to the UK from Pakistan in the 70s, after marrying my father. My sister Kiran was born soon after. Although she was educated in the UK, she moved to Pakistan when she was nine and was back and forth until she settled in the UK with her own family.

When I was growing up in the 80s we were in Smethwick, where I am now. For me, Birmingham has been the perfect image of Britain. I think the city is what Britain stands for – we're very tolerant. I've seen the issues that people are facing in other areas that aren't present here, so it's made me appreciate Birmingham more. Growing up I had friends from all different backgrounds and my family have always been very integrated. I never really saw any racism; I never saw any differences between the people here. Racism wasn't something that even crossed my mind.

The word 'Islamophobia' was something I learnt sometime after 9/11. Until then, I didn't know what it was. I didn't know that it was called Islamophobia until it formed into this thing that had a name.

After 9/11 things started changing in my family life. I noticed my own siblings not realising I saw changes within them. One particular sibling, actually. It started to affect the whole dynamics of my family, because if someone very close to you is not feeling right, it's going to create a ripple effect on the rest of the family – and we didn't understand how to fix it. My mum always made it out like it's not our problem, it's not happening here, don't worry, it's not going to affect us. But actually it did start to affect us, and that's when it became more real. It was a problem I felt like I couldn't ignore any more, because it was everywhere: where I was studying, in my own home, in the treatment of people around me.

I got into activism because I felt like my own circumstances – the way I was brought up – made me stand up for the right thing. When I heard about the Islamophobic attack on my own sibling and the effect it had on him – it totally changed him and made him ill – it was the first time we realised how dangerous it is for someone not to feel part of society and not be happy with the way they are, or who they're around.

We set up an organisation called Odara, which is derived from the Brazilian indigenous Yoruba word *dara*, meaning beauty. Odara is a support network for women, which creates a safe space where women can come and educate themselves, or relax and focus on their wellbeing. It's an all-round care package. We like to offer personal, professional and social development opportunities. And this means personal care, mental health care, and even just helping to develop skills people need to be the best they can be within themselves.

We educate people in real issues and help them come up with solutions. We take on referrals for the most vulnerable women, and families who are suffering because of issues relating to Islamophobia or extremism – for example, a family member who has turned to extremism, which has had an impact on the whole family, as we know it can.

Ideally we'd like to start acquiring more offices and safe houses, which vulnerable women can use as refuges, and we would love to look after women on site until they can live independently. Something else we're working on is inspiring more social entrepreneurs to do what they want to do in their communities. We've seen so many people with the potential to do the same or even more than us. They don't know what they're capable of until they get the right guidance and empowerment.

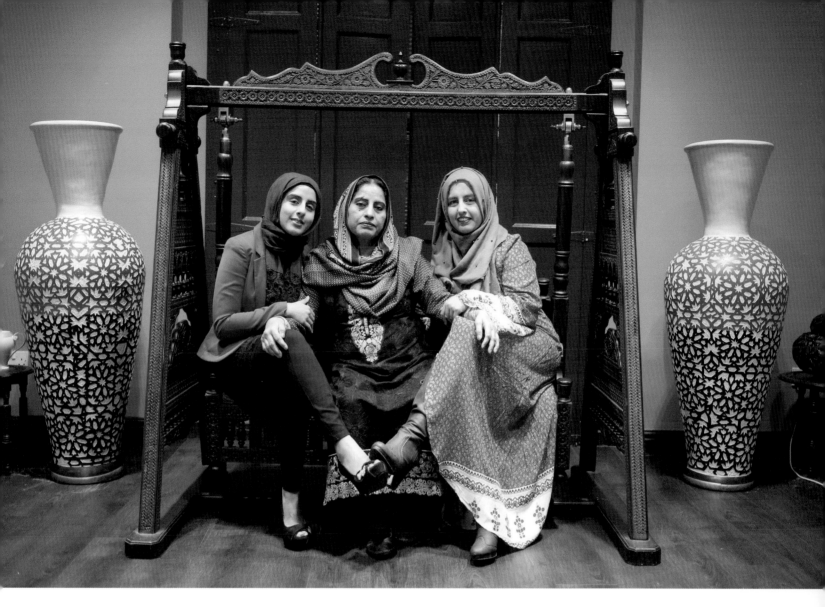

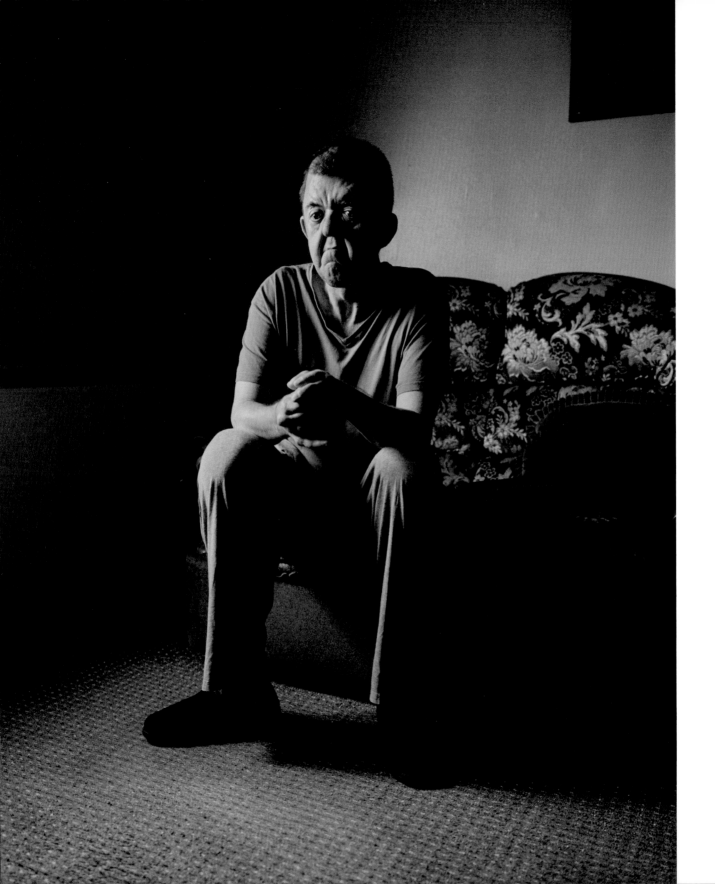

Carl
Dereham

The state of the country is terrible. Don't even get me started. Theresa May, she gets on my nerves when she goes on.

I live at the Maltings in Dereham. The trouble is with all the flats here and the housing – nothing is decorated or anything, nothing is getting done. The windows need a lot of work doing and in my eyes, the council don't seem that bothered. You tell them about things but nothing gets done.

There's people doing drugs here and I can't see it changing. It makes me feel scared. The fire alarms went off and I didn't know until the next morning that someone put something in the microwave and left it on. If there was a fire like Grenfell in London, where all those poor people died, how on earth are you supposed to get out of the building? What are you to do? You can't jump out of the window, because we're on the second floor, and if you jump out of the window you'll hurt yourself. If it's on fire in the corridor how are you supposed to get out?

I don't know how the councils and the people in charge are able to get away with this. For me the councils just don't give a damn, because they don't seem to want to know – they just think of themselves.

The state of the country is terrible. Don't even get me started. Theresa May, she gets on my nerves when she goes on. There's stabbings, murders, fires, she says she's gonna sort these things. Like Brexit, one minute she's saying this, and the next another. Like the fire in Grenfell, all those people, all the people in Manchester. This government, this country – it's just got worse. I quite like Jeremy Corbyn because he's straight to the point.

I saw a picture on Facebook; there was this girl in London, it was the Royal Wedding – and good luck to them – but there was this girl who was homeless and the police went and moved her along when she wasn't doing anything wrong. It makes me laugh, because they say they're going to help the homeless, but what are they doing for them?

In the winter it's very cold in my flat. My neighbour next door to me, he's in his sixties and it's also very cold in his place. Because we've got expensive storage heaters, the council don't seem bothered to do anything. Sometimes in the winter, when it's snowing or cold, I don't go out, because if I fall it's dangerous. So many people have fallen on the steps outside these flats. I have been caught out in winter because I've been too frightened to go out.

You think of the poor people out there, think of them in the winter in the freezing cold, all because of money. The council just want money, and when they don't get the money – or if you're in rent arrears – they evict you. Why don't they go to these people and say 'We're going to help you sort your rent out' instead of evicting them? It's crazy isn't it?

PHOTOGRAPHER: J.A. MORTRAM

Emily Jones
Doncaster

I struggle every day. I struggle to get up and even make myself food, and so I skip meals quite often.

From a very young age I was getting Disability Living Allowance (DLA). My mum received the payments until I turned 16. I struggle every day. I struggle to get up and even make myself food, and so I skip meals quite often. I can't really explain what sets me off all the time. Sometimes it can be the most random thing. My brain is always 100 miles an hour and I can't think straight. I can't just take any job – even the thought of it gives me really bad anxiety. I can't do a sales job. I've tried. Every day I went there I was breaking down.

Eighteen months ago my DLA was stopped, and I had to go through a Personal Independence Payment (PIP) assessment. I was asked a lot of questions about whether I needed assistance. It felt like I was being classified as physically disabled, rather than mentally. I wasn't asked any questions about how I get through everyday life. There was one point near the end where I started to have a panic attack because I was being asked questions that I wasn't comfortable with. I had to do some equations, which I struggled with and stressed me out. I started panicking and crying, and the assessment had to stop. When I got my letter back from them, they said I was completely fine in the interview and didn't have a panic attack. They completely lied about what happened in the assessment.

A friend got in touch about an editing job in a photography studio. Most of the time I'd be on my own, so I could concentrate on what I was doing, which is good for me. Socially interacting with people is a massive struggle. It was zero hours, with no sick pay, and work wasn't guaranteed. Some weeks I wouldn't work at all, and my pay would just cover my rent. I was only doing one day a week to start off with, and then it went up to four days. Swinging between extra work and no work, my health started to decline, so I had to tell my boss that I was getting really stressed out. I don't think she had any interest whatsoever in my health; she was being mean to me, bullying me, in a sense. She said she didn't have time for people like me and told me to leave work, so I decided not to go back.

I'm not working now. I've had another PIP assessment. I've got four weeks to wait, to see whether I'm getting it or not. If I get it, it'll be a lot less stress on me. I won't have to constantly worry about having enough money for food and stuff. Right now I'm on Universal Credit. That's how I'm keeping my head above water. I'm not getting any sort of disability money. After a certain period of time I'm going to have to start looking for work. It's different for me because I have got disabilities that stop me from doing certain things. But if I got PIP I wouldn't have to go every few weeks for a check-up. I could come off of Universal Credit.

Looking forward, I can only do certain work. But working with people constantly, all day long, I can't do that. So I'm going to focus on doing photography. It'd be great if I could just sell my prints to get money in. That would be great for me.

PHOTOGRAPHER: LES MONAGHAN

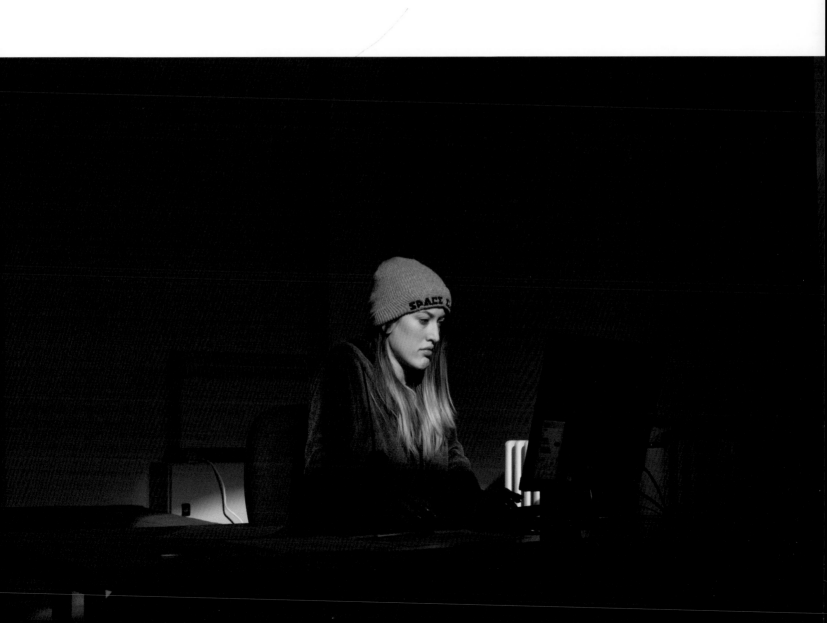

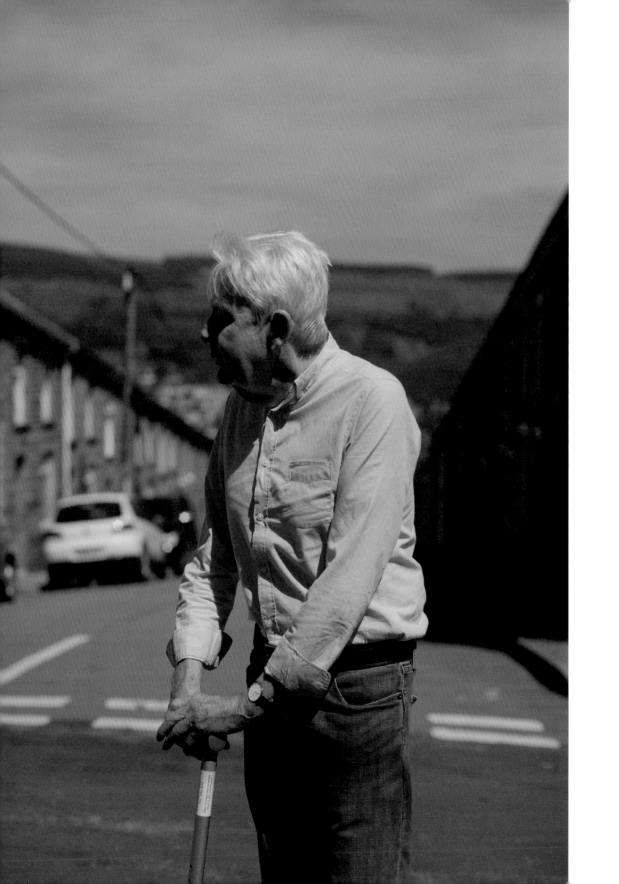

Keith Griffiths
Aberdare

At first I thought it was a good thing to go on strike, but it became clear that Maggie Thatcher was going to close us down all the same.

I was born in Aberdare, and grew up with my parents in the neighbouring village of Trecynon until I was about 25. I've lived in my current house since 1973, so coming up to 45 years. At that time I worked in the local Phurnacite works, which produced a kind of smokeless coal for central heating systems.

I worked as a Time Keeper, clocking the workmen in and out, and making sure they were paid exactly what they were owed. By the time the plant closed in 1991, I'd worked there for 28 years – the site has remained empty ever since. The ground the works stood on is still polluted. I think the intention was to knock it down and build houses, factories, or whatever on it, but nothing's materialised.

For the younger generation it's probably hard to imagine having the same job for as long as I did, but it didn't really bother me. We went to work and if you enjoyed it, well, that was fair enough. You didn't look elsewhere for another job. In the 60s you could also move from one job to another – you could walk out of one job and start on the following Monday. But that wouldn't happen now.

When the miners' strike hit in 1984, I joined the picket and looked after my daughter while my wife went out to work. It lasted for almost a year in all. At first I thought it was a good thing to go on strike, but it became clear that Maggie Thatcher was going to close us down all the same. It was a tough winter that year. There was no money coming in, so obviously there was hardship in that. But as for anything else, you just got up in the morning and got used to it.

I remember I was growing vegetables around that time: kidney beans, cauliflower, cabbage, potatoes, and they were coming fine. I used to water them nearly every night, and then I went away for a week to the caravan down in Pendine. When I came back, I went to water the veg and there was no veg there. The striking miners had jumped over the fence and taken them. The wife wasn't very happy about it, but it's just one of those things.

Eventually, the strike ended in 1985, and production resumed with a reduced workforce, what with the redundancies. We were processing coal from the local mines until 1991, and after that it was just mass unemployment. Not much has changed since then. There has been a slight improvement, but there are still a very high number of unemployed people around here. Maybe some want to be unemployed, but many can't find a job – it's very difficult.

On the one hand you can say the local environment is a lot cleaner now than it was, because obviously the pollution that came from producing Phurnacite was tremendous, and it was killing off trees and all that. Now it's greener and there's cleaner air as well. But for me, employment comes first. Pollution is something you have to work around, and try to reduce with time. If you're not working you might as well be in the earth, and feed the cows.

PHOTOGRAPHER: JON POUNTNEY

Jasmin Parsons
Barnet

We're still dealing with feudal law when it comes to housing, so we're really up against it.

I've lived on the West Hendon estate for more than 30 years. There are people here who've lived on the estate all their lives. People have known each other for decades and for generations. They have deep roots here.

Regeneration of the area had been talked about in broad terms since the early 90s, but it was the change in local government that enabled a switch in direction; suddenly it was the council homes in West Hendon and Graham Park that were targeted as a cash cow for the council.

As part of the community consultation, a 'pledge' was signed between the council and residents, agreeing to a regeneration programme that would see homes upgraded and some partial demolition of the older homes. That legally binding pledge was later ripped up and the residents' choice of developer mysteriously dropped out of the contract to be replaced by Barratt. We knew things were starting to go drastically wrong.

Despite being legally obliged to consult with residents, we were left out of meetings and items we raised were left off the agenda. When the council sold the estate to the developers for £3 without securing any of the housing rights – whilst simultaneously billing residents for £10,000 repairs to their homes despite impending demolition – we started the Our West Hendon campaign.

Our original aim was to try to save the estate, but as that increasingly became less likely, the next priority was to ensure that everybody got treated fairly. That means that tenants got rehoused and homeowners got the proper reimbursement. Although that hasn't really happened in the way we would like it to, we've gained far more for residents than what they otherwise would have got if we hadn't done anything.

The moon, stars, sun and sea are promised with these regenerations. As soon as planning permission is given, then a viability study comes in and the majority of the social housing and social benefit gets dropped, with the blessing of the council. Not that the figures ever become public. You need to get your objections in before that and get as much press as possible so that there's public awareness. Without the residents having an authoritative role in the scheme from start to finish, developers can use a viability study to reduce or remove public housing, which they often have no intention of building when they bid for the scheme or seek planning permission.

Organising people early on is vital for a proper campaign, as is starting a fighting fund to pay for things like t-shirts, posters, travel, covering unpaid leave to attend meetings, and representing residents at court or council offices in the public inquiries. My best way of preparing to fight politicians, developers, housing associations and other organisations is to do my own case and then anybody else who wants to come along can bolt on too. The resources, money and connections that housing associations and property developers have are massive. And the law and regulations are stacked against you as an individual.

We're still dealing with feudal law when it comes to housing, so we're really up against it. No government or council is elected and given a mandate to sell public property or land. They are elected to manage it, yet here they are selling it off lock, stock and barrel. They're literally taking the land and the property away from the public. It's theft by conning people.

PHOTOGRAPHER: GINA LUNDY

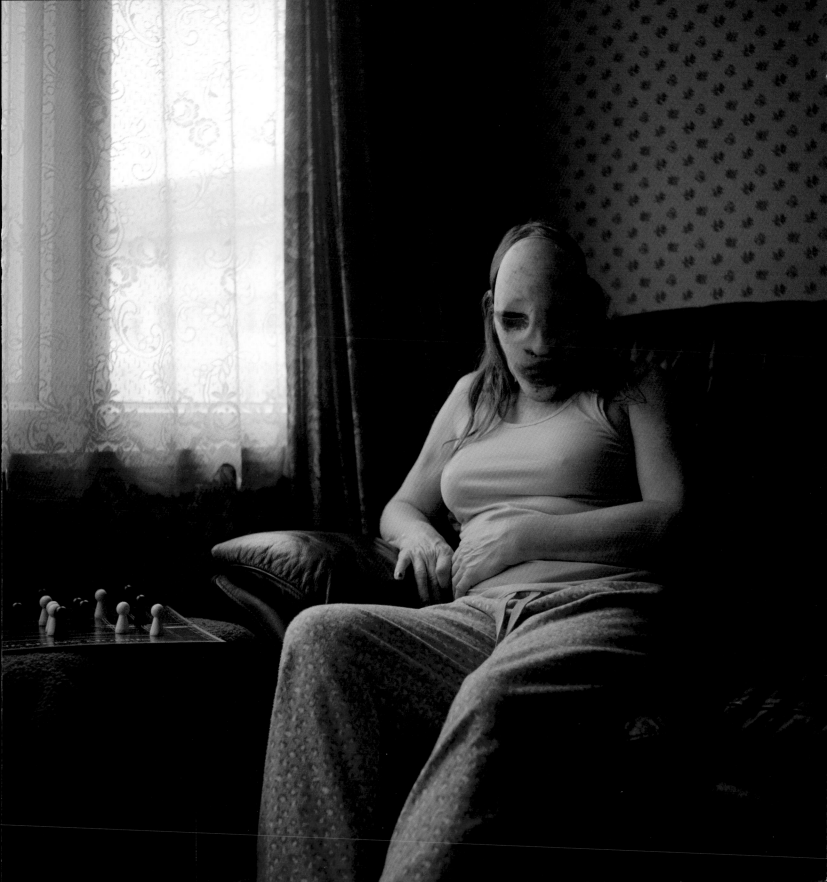

I've heard it described as a battle, but
for a battle both sides had to be armed.
They had riot gear, helmets, padding,
gauntlets, shields, three-foot batons.
There was only one side armed.

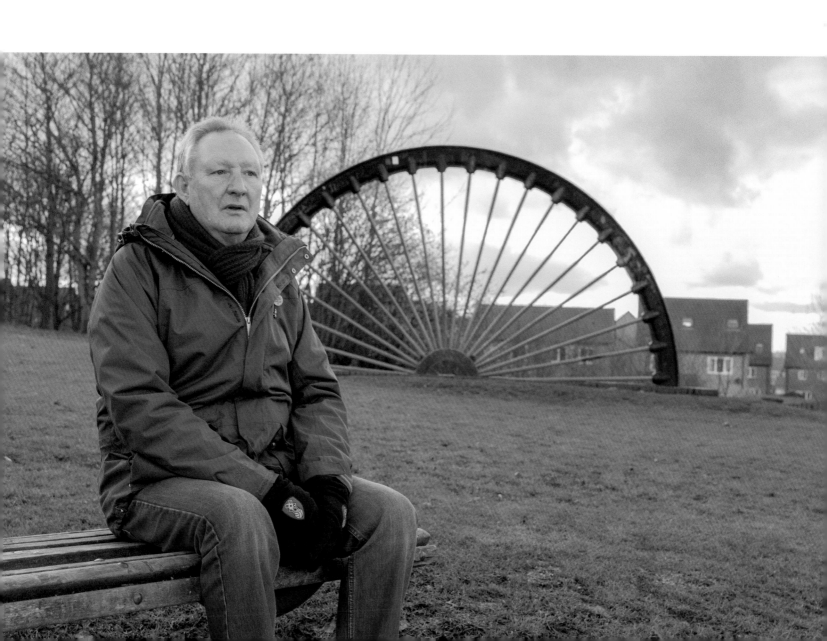

Kevin Horne
Mexborough

When the miners' strike started in March 1984, I was 35 and had been working at Barnburgh colliery for seven years. My arrest at the Battle of Orgreave on 18th June that year has led me and my family to not trust the law ever since.

At Orgreave there must've been five or six thousand police marching up and down in ranks. As we got closer we could see lots of police without numbers. My mate said to me, 'That's army', and I said, 'How do you know?' He replied, 'Because I've just come out of the army.'

I've heard it described as a battle, but for a battle both sides had to be armed. They had riot gear, helmets, padding, gauntlets, shields, three-foot batons. There was only one side armed.

We were locked up in Snig Hill police station in Sheffield and then transferred to Rotherham later in the day. That's when we saw all the injuries. There were so many policemen wearing overalls and no numbers. Some were wearing overcoats and that day was probably the hottest day of the year. The pickets were shirtless and the police had overcoats on – what's all that about?

At the Orgreave Truth and Justice campaign, we've had photographs sent to us and testimony from people who think they saw their sons on the picket line who were in the army, or miners that saw their brothers. Although there were 18 police forces there, we don't think they could've accumulated that many police. We think the soldiers were there and some of the police were army people dressed up.

There's a lot of questions that need answering. Who was in charge? Why were there police without numbers? Why did they let us in that day? I know that the Association of Chief Police Officers (ACPO) files are in the University of Hull library and they're embargoed until 2066.

Now, every miner will be well dead by then. We need to get to the bottom of it while some of the miners are still alive.

We were criminalised. There were 11,000 men arrested; these men who have never had a blemish on their police record suddenly became criminals. We want to clear people's names, especially the people that have died.

I like to think I'm speaking for the people that have died since then, the people that were arrested or have died, the miners that have died or are too ill now with lung disease and other things to speak for themselves. Bernard Jackson, who was on the first trial, died and I'm now in touch with his grandchildren and great-grandchildren. They want justice, they want Bernard's name clearing. There's also David Bell, who was on the first trial and later on went down to London and threw himself off Westminster Bridge.

I've spoken to Theresa May; she didn't look as if she was listening. I've spoken to Amber Rudd, and she hadn't even read the legal statements we gave her. When we went for the interview she said, 'Remind me what you're here for?' We hope that the new Home Secretary, Sajid Javid, will do the honourable thing and look at our legal submission, read it thoroughly and grant us an inquiry.

I've done a speech in the House of Lords and the House of Commons. Before I die I'd like to see an inquiry into Orgreave. I'm working on it, lots of good people are working on it, and eventually the truth will come out. I just hope I'm here to see it and I hope lots of other miners are here to see it as well. I'd like to see a bit of sunshine after this dark winter.

PHOTOGRAPHER: DUNCAN STAFFORD

Liz Crosbie
Govanhill

I was born in Govanhill and lived here until I was 30 years old. My mum still lives here. I'm not saying it was the greatest area in the world, 'cause it wasn't, but everybody kept pride in their back courts and they were clean. We'd go out and play wee houses in the street because it was clean enough. You never had all this scattered rubbish everywhere. The houses are overrun with mice, bedbugs and cockroaches. Things that you don't hear of in 2018.

Two years ago the crime rate was terrible. We've had murders in the area and sexual assaults through the daytime. All our elderly pensioners were terrified to go out due to the number of muggings. There were even cases of robbers going into people's houses, beating them up and robbing them.

If you mention Govanhill, people will say, 'Oh I'm not going there, I couldn't go there.' It's just got that taboo now about it. At the Edinburgh Festival they did a play set in Govanhill called 'Govanhell'. Why would people in Edinburgh even know about Govanhill? That's how bad it is.

Govanhill Housing Association own most of the properties here, so we thought if we went to them they're going to sort it, because they're meant to be a reputable company. But they were blaming the private landlords, the private landlords were blaming Glasgow City Council. They're all just blaming each other.

We started the Govanhill Community campaign in 2011 to let everybody know that this place is a filthy mess and the authorities need to sort it out. There were loads of meetings with Nicola Sturgeon, loads of arguments with the police, but nothing was getting done. So we started a petition with a list of demands to improve the area and make it safer, and marched to Nicola Sturgeon's office to deliver it. Things have slowly started to improve since then.

The crime rate has gone down considerably since the CCTV was installed and the police presence was increased. People feel safer walking around the streets during the day, but are still afraid to leave their homes at night, as the gangs that hang about on corners can be very intimidating.

Govanhill is the first place in Scotland to become an enhanced enforcement area, which gives the authorities the right to remove properties from rogue landlords who are exploiting tenants by letting out one-bedroom flats to 15 or more people, and not maintaining the flats to a decent habitable standard. Govanhill Housing Association has bought back a lot of the properties and they are being renovated to be re-let in order to deal with the overcrowding in the area.

But there's still not enough housing and they're pulling houses down and not rebuilding. Every other area around Govanhill – the Gorbals, Pollockshaws and Toryglen – have all been regenerated. But they've done nothing in Govanhill. Our campaign is asking why nothing's getting done here. Why is all this money put into other areas while nothing gets done here?

I think they've got plans for Govanhill. I think they're waiting till they get it right run down into the ground, where you can't do nothing with it. Then they'll get everything cheap and then they'll rebuild it.

I still love Govanhill. That's why I fight for it.

PHOTOGRAPHER: ROBERT CLAYTON

*At the Edinburgh Festival they did a
play set in Govanhill called 'Govanhell'.
Why would people in Edinburgh even
know about Govanhill?*

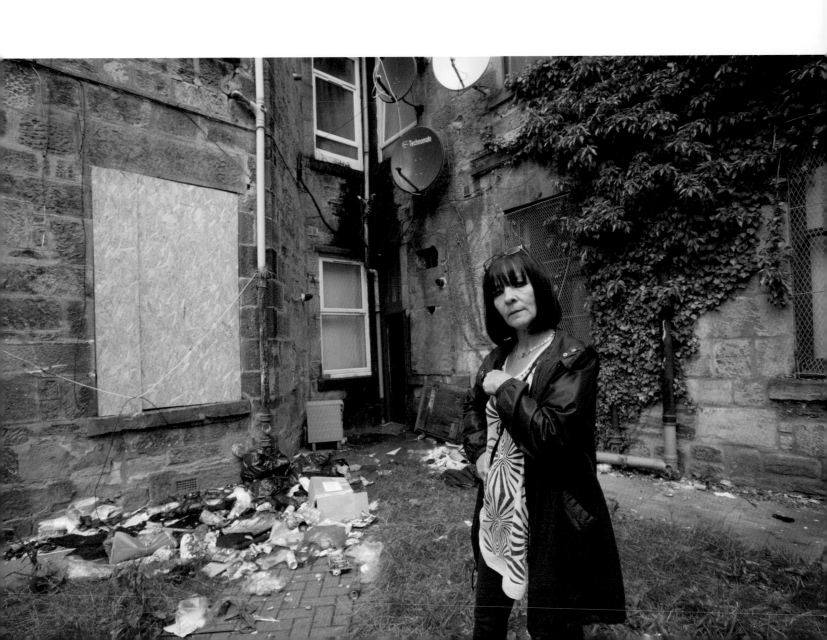

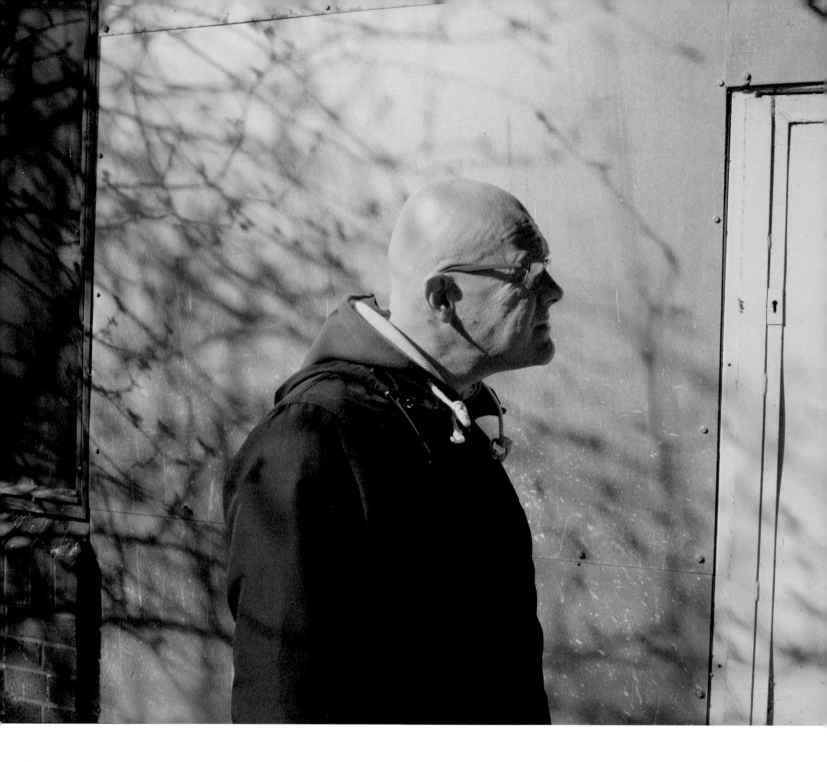

Matthew Graffham
Hemel Hempstead

The recession started again, hitting the building trade, and there was lots of pressure trying to keep everything together for the family. Things started to go wrong.

I was born in Leatherhead in Surrey in 1970. I had a good marriage, two daughters, then round about 2007 I lost two very close friends. One was a guiding figure and he just dropped dead. Second friend, he was killed in a motorcycle accident.

In 2008, I wasn't coping really well. The recession started again, hitting the building trade, and there was lots of pressure trying to keep everything together for the family. Things started to go wrong.

I started to drink. Not heavily, but it was a support mechanism, trying to forget things. I didn't realise, but depression started to creep in. I was becoming more distant from my family, losing interest in things that I enjoyed and loved, and eventually got into trouble with the police.

At this point the country was in full recession. There were lots of spending cutbacks. I was going to probation once every fortnight. Because of the cutbacks I was seeing a new officer each time. There was no continuity. I'd tell my story, and in the following weeks I'd see a totally new person and had to tell the story again. I was never achieving anything. We were wasting each other's time. I stopped going. This landed me back in court and led to a 12-week prison sentence.

I was in prison in Bedford when my wife moved out of the marital home with the children. I discovered she was having an affair. She moved in with her boyfriend somewhere in the depths of Oxfordshire. It was a good thing I was in prison at that time, otherwise I would have got myself into a lot more trouble. It gave me time to get over it, think about it, by the time I was released. Although my wife is still supportive, I came out of prison to the family home and it was empty.

Eventually the house was repossessed and I found myself having to find somewhere, renting a bedroom in Hemel Hempstead. But offences led to more prison time, until I was released in April 2017. And that was me done.

I was a free man, but I had nowhere to go. I had the travel warrant made out back to Hemel Hempstead, where I knew the layout. For the first couple of nights I got into a B&B, but after that, no job, no benefits at the time, nowhere else to go. So I was sleeping rough.

I always had in the back of my mind that something would come up. And I was always looking for that opportunity. I presented myself to the council as street homeless: no help. It was a case of head down, sleep rough.

The first week was a bit of trial and error in finding places to sleep, whether they were good or bad, which is why I ended up sleeping around the hospital: my 'central point'. I knew the air conditioning units; if it was that cold I could at least find some sort of heat. Washing facilities; I could make myself look presentable. If you went into the disabled toilets you could change your clothes. You felt human. Which was half my battle.

I got a call one day out of the blue. 'Come to the Elms homeless shelter and you can have the crash pad, and if all's well after four nights you can have a room on the Monday.' It's allowed me to take stock, rebuild. I've got to get out on my own, which is what I'm working to doing now. I want to work, which is what I need to be doing. So when I step out those doors, it's going to be the last time I ever do it. And it's going to be the right way.

PHOTOGRAPHER: LOUIS QUAIL

Marie McCormack
Glasgow

I think applying for benefits is made really hard just to put people off. It can be the most stressful, soul-destroying thing ever in your life.

I have lived in Glasgow since I was about eight years old. Nowadays I've got a great circle of friends around me who have supported me and helped me do things in life that I thought were not possible. Years ago, I was made redundant and I didn't know what to do with myself. That went on for two years; it was terrible. I just shut myself away from the world. I didn't have any push, any encouragement, so I just sat in the house.

It's all around us, people like that, people who are going through the same thing, not getting helped by anybody. Many of us are just a wage packet away from being in severe problems. We are all vulnerable.

Eight years ago a group of us sat at a kitchen table just around the corner from here, talking about how decisions about poverty must involve us, the people who are experiencing it. Olivia was in my tummy when I first sat at that table, and from that the Poverty Truth Commission was set up, which I have been involved with ever since. Poverty isn't just about money. It's also about things like education and housing.

Everybody wants it better for their kids. I wish there had been a lot more encouragement in my childhood, so I try my hardest now for mine. I don't want my kids to be on benefits, in the system. I had a hell of a time on it myself before I got a great opportunity with where I work now at Bridging the Gap. We run a kitchen in a block of flats in the Gorbals, where we bake fresh bread.

People from all walks of life come in and get involved with us, bake with us: locals in the area, refugees, basically people who are vulnerable for one reason or another. It's about sharing, working together and getting people involved who live in the community, people who have great skills.

I get a living wage but I am always worrying about money. Sometimes it's still a question of fares for the bus for my son to go to college, or putting food on the table. I receive some benefits and I'm dead grateful for that money, but I wish I could get away from it. I think applying for benefits is made really hard just to put people off. It can be the most stressful, soul-destroying thing ever in your life, because nobody communicates with each other. The phone calls you've got to make, the time it takes to get through, the forms you've got to fill in. I think they do that to make it fail, for people to give up.

At the end of the day we are all just human. People don't want to be felt sorry for; they just want to be heard. They are human beings and they are trying their best – I am trying my best.

What do I want for my children's future? My son is at college getting an education, and I hope for Olivia that she is encouraged in her education too. But I also hope that Olivia carries on the things I do, to have compassion for people and just fight for people's rights, for justice and for hope.

PHOTOGRAPHER: MARGARET MITCHELL

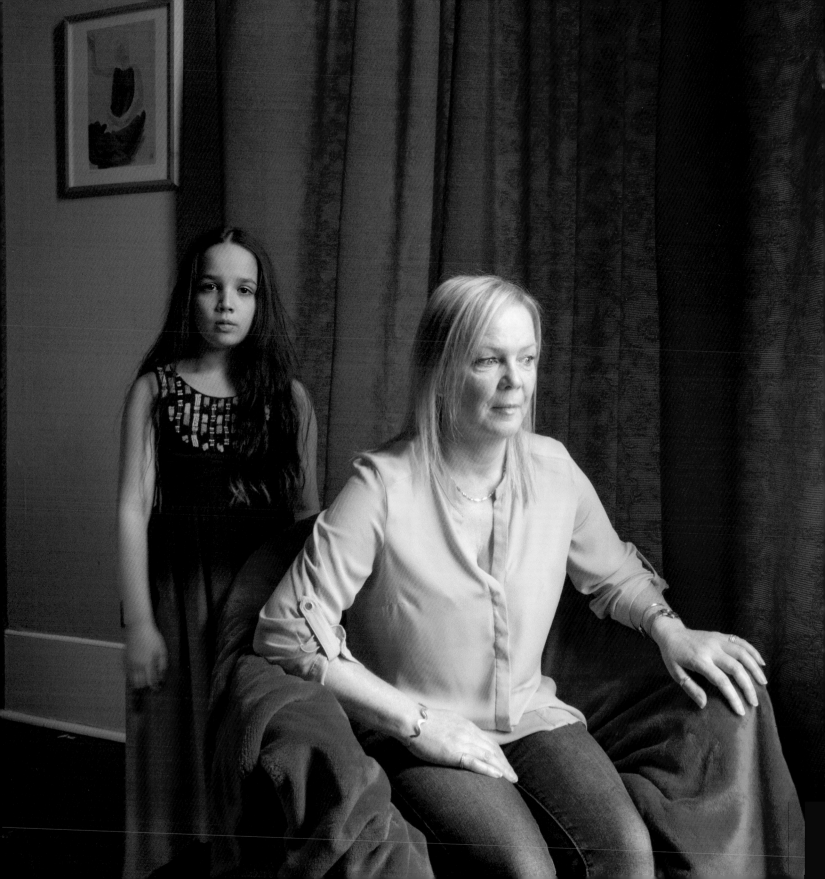

People here don't want a border back because of all the trouble there was. There were a lot of bombs, over at the garage. The windows of this pub would be put in from the bang of the bombs.

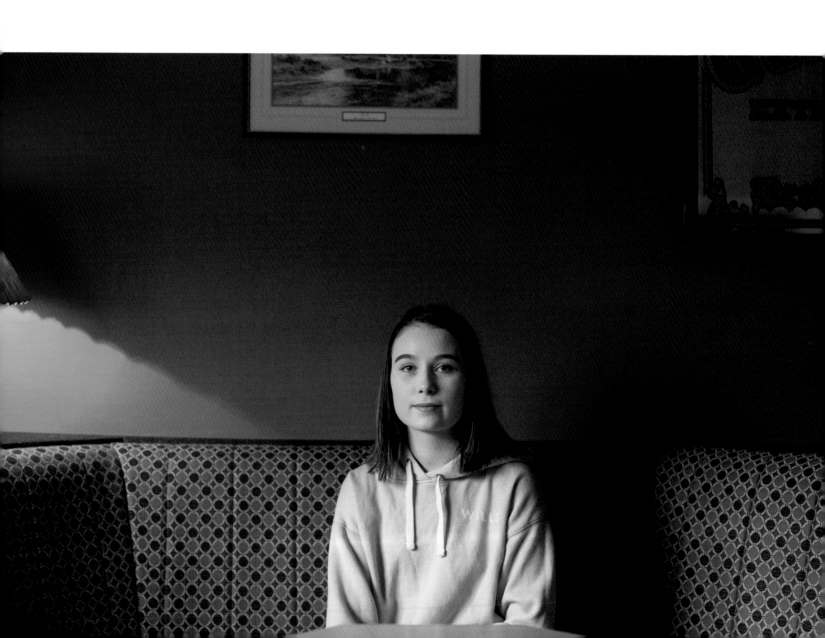

Michelle Moss
Pettigo

I was born in Pettigo and still live here, in Britton's Bar. It's right on the border between Northern Ireland and Southern Ireland. The pub is in the South, but our garden is in the North. Granda used to grow vegetables over there, and had to cross through the river to get them.

People here don't want a border back because of all the trouble there was. There were a lot of bombs, over at the garage. The windows of this pub would be put in from the bang of the bombs. Pieces of metal from the bombs and the cars blowing up would fly through the windows. Mum and her family would have to leave when there were bomb scares. They wouldn't want that back again, and the Customs constantly stopping and checking you. They're hardly going to be stupid enough to bring in strong borders and have a lot of bombs going on again.

I go to school in Ballyshannon. I was in Pettigo Primary School before that. There's only one bus that runs to the South, so Ballyshannon's the only school I can go to. You usually have to live in the North to go to the Northern schools. There's generally one person every year or two that goes to the North. There's only 50 or something in the whole primary school.

I probably would have preferred to go to school in the North, but because everyone else in my class apart from one was going to the South, it's just the done thing, because that's where the bus is going. If you went to school in Enniskillen, there's buses home to Pettigo all the time. But in Ballyshannon you can only get your school bus home, so you're snookered.

I'd like it if more children were being born in Pettigo, so the primary school would be fit to stay open. A few families always send their children to the North, and their children then send their children to the North. Because Pettigo is split in two, Tullyhommon is in the North, but it's still classed as part of Pettigo. Basically, every family that lives in Tullyhommon sends their kids to Kesh, and then on to Enniskillen. It's not hatred between them, but it's just the way people do things. We do have festivals, and it's all cross-border. Things like that bring the two communities together.

If you live in Tullyhommon you go to a Northern school, and a lot of them don't go to the shops in Pettigo. People lose out with their friends, too. If you go to primary school in the South, you make friends in Pettigo because we're all so close and you'd go out playing in the evenings. If some people in your class are away to the North, then you kind of lose contact with them. You can't have the same conversations about different teachers or people at school. And that's hard when you're in a small area. They're kind of segregated, then.

The border issue isn't something that really affects people of my age, because I've never known there to be a border. You don't really think of smuggling carrots over to home and this sort of stuff. I just hear old people going on about it all the time. The whole Brexit thing came in, and I don't know what's going to happen. But I wouldn't want there to be a border. At the same time, I don't think it's going to make much difference to me because I don't know what it's going to be like until it happens – if it happens.

PHOTOGRAPHER: KATE NOLAN

Ronda Daniel
Dagenham

In my first week at the London School of Economics a student told me I was part of the underclass because my family received benefits, and a lecturer said 'Poor people don't come to LSE'.

Where I come from and the way I grew up has shaped everything about me – it's something I carry with me every day. I thought I was just normal: lived in a council house, went to school, came home. Got a job at 16.

When I was 12 my mum told me about a book called *Chavs*. She told me about how people's lives were valued based on where they were born and what their parents did. It all sounded a bit Victorian to me at first. But after being so exposed to how people are perceived as scum or lower than anyone else, I realised that our lives aren't valued the same, and that we're not all equal, even though we should be.

I was always bright at school. I took part in schemes to get me to go to university, but it wasn't what I thought it would be. In my first week at the London School of Economics (LSE), a student told me I was part of the underclass because my family received benefits, and a lecturer said 'Poor people don't come to LSE'. I felt that all that hard work was for nothing and that no matter how much I contributed or how well I wrote, I didn't belong there.

This prejudice carried on throughout university. And whilst I had a great group of friends, I felt that because class isn't a protected characteristic, the way I felt wasn't real, or was something that could be torn apart and deconstructed.

All of my research was about the impact of media representations of working-class people. The trigger that brought me to study sociology is because I wanted to understand how this could happen so easily, and why people just took this in without questioning it.

I remember a teacher at sixth form talking about a study called 'Perceptions are not reality', where people hugely overestimated statistics on immigration and benefit fraud.

I didn't realise until I went to university just how much of an effect my upbringing and my town would have on my outlook on life. I realised that not everyone was like me and knew about benefits or had been on free school meals, had seen someone they went to school with go to prison or had any friends my age with children.

Looking back, I realise how valuable my upbringing was. In all of the cases we studied I didn't just see them as participants – they were people like me. Now I've left university and I see tragedies every day on the news about murders and deaths from benefit cuts or housing being demolished, I don't deconstruct it like a sociologist. I look at it as a person, as if they were my friends.

With two other students from LSE I helped set up Britain Has Class, which brings together grassroots campaigns and working-class voices from across the country. We try to uncover how class permeates throughout society and speak to people affected by real issues, such as housing, austerity and prejudice. We proudly held our first conference in March 2018 and now we're aiming to work at a local level to amplify communities' voices and challenge politicians and the media.

I love my town and I'll always value the things university didn't teach me as much as those that it did. I value my life experience, my ability to put myself in other people's shoes, and perhaps most importantly, my ability to tell stories.

PHOTOGRAPHER: TYLER WATT

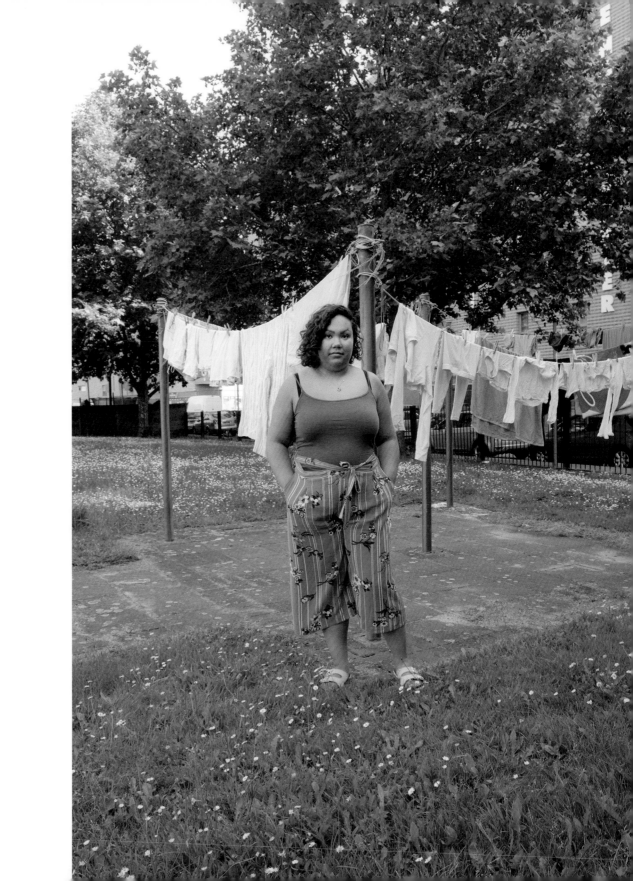

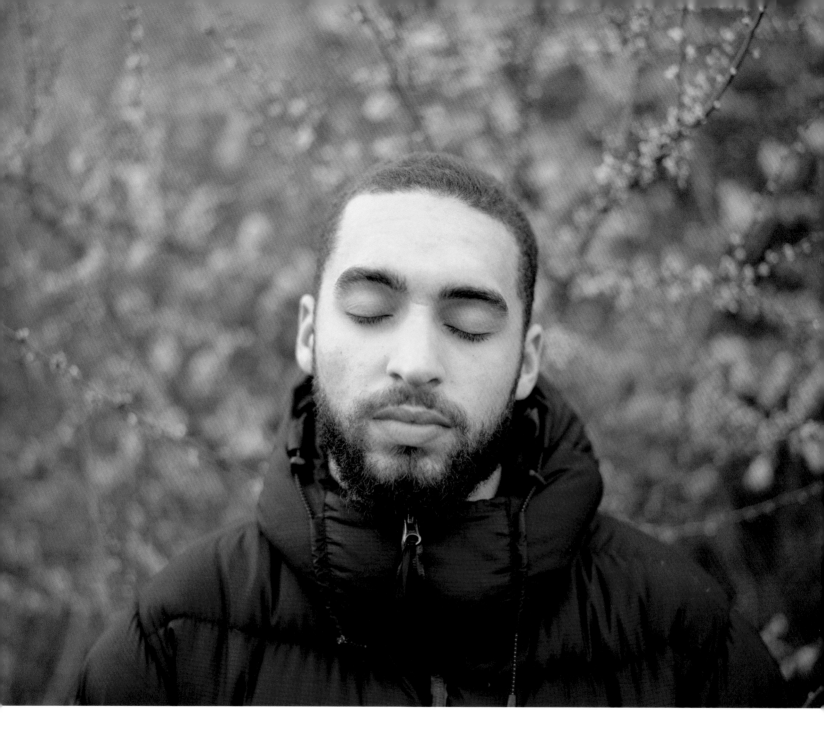

Sé Oba-Smith
Islington

Mental illness isn't universal. You can't just give somebody one thing and they feel better. Everybody has their own way of coping.

Gregory Fredrick Watson was my cousin. We became like brothers when I turned 16. Facing depression myself, I found Greg intelligent, having dealt with many issues himself growing up. He had a very down-to-earth perspective. He was loud, he was funny, and he was very honest. He gave me advice and mentoring through tough times, something I tried to do back. Unfortunately, he committed suicide last winter, aged 26.

After Greg's mum became pregnant with him, she had psychosis and entered a very dark place. This was worsened by the various medications prescribed to contain her condition. She had no ability to care for herself. When Greg was born, our family wanted him to be taken away from his mother. We thought she would struggle with a young child. His father was adamant that they could look after him, shouldering the burden of a young child and a mentally ill partner. As Greg grew older and his mother's mental state worsened, his dad slowly began to lose his grip. Greg was neglected emotionally and physically.

When we were kids, our Uncle Nnamdi hung himself at the age of 22. Greg, my brother and me all idolised Nnamdi. His suicide deeply affected the way we all see the world. Greg said that he first started feeling suicidal at the age of 12, when he started secondary school. He was bullied extensively and was hit by his dad. He changed massively in appearance and attitude in order to cope. The bullying was based on his mum's condition, his mixed racial heritage and his sensitive nature. As Greg got older he dropped out of college to look after his mum and to reflect on his life.

Once his dad left home, Greg was the last one left and became his mother's carer. After his dad died in 2015, he ended up having a breakdown, due to the bad relationship he'd shared with his father and the deep regret for what they should have had. He also thought about his mother's mortality and questioned his place in the world without his mother.

Greg tried to commit suicide a couple of months later. He told me he was about to jump out the window and said to his mum, 'Shall I jump?' and she replied, 'I don't mind. It's up to you.' He got down, grabbed a wire and began to strangle himself, shouting, 'Tell me not to do it – stop me.' He suffered with psychosis and began reading into and creating connections with everything. Shortly afterwards Greg moved in with my mum and his mental health started to improve slowly.

In the summer of 2017 he broke off contact with most of our family. Then in winter he contacted my mum asking for help to get his mum to a hospital. He had stabbed himself twice in the stomach that day in guilt and frustration at her condition, having also previously tried to harm and kill himself multiple times that year. He spoke to my mum daily as she tried to get him away from the guilt and depression. Three weeks later he was found dead.

I had seen Greg three days previously to try and help him. He'd been extremely vulnerable and subdued. From 2011-2017 he made multiple cries for help. He went to his GP and asked for help with depression and the other mental issues he was facing. He was admitted into hospitals whenever he harmed himself. He called hotlines trying to get help. On each occasion the response was the same: he was prescribed with antidepressants. He took the drugs for short periods, but found no improvement and stopped.

Our mental health system is Victorian. Often it's only reactive when it's too late. You can only get counselling promptly if you harm yourself. Mental health is increasing in people but the funding is lowering. Mental illness isn't universal. You can't just give somebody one thing and they feel better. Everybody has their own way of coping. Asking for help is a big deal and shouldn't be shrugged off until someone gets worse. We need a more proactive mental health and educational system, alongside more counselling.

PHOTOGRAPHER: CIAN OBA-SMITH

Malgorzata Jaworska
Merthyr Tydfil

When you're an immigrant you feel like an invisible part of Britain. Until you're ingrained in the culture, you're not seen or heard.

I moved here from Poland with my family in November 2005. When I first arrived in Merthyr, the area seemed to be very closed off, especially if you were an outsider. It was still very much in a 70s time warp, dominated by working men's clubs and untouched by multicultural experiences.

The change in Merthyr is very visible over the years that I've been calling it my home. I guess people aren't scared of the unknown any more and are now more open to change, which means they are now willing to expand their horizons and look further than the working men's clubs.

As an interpreter I connect two cultures together: Welsh and Polish. When you're an immigrant you feel like an invisible part of Britain. Until you're ingrained in the culture, you're not seen or heard. Your voice doesn't count and you learn to live with it until you're given that voice, through opportunities, through people, through the media. That voice started to exist, it gave us an identity and introduced us to the world, but the way things are heading it seems like we will fall below the visible line once again. It'll just be Britain and a bunch of its immigrants as separate entities.

In very simple terms, I think the Brexit vote was very much driven by fear, and I think that journalists fabricated the reality. I think Britain should have stayed, and I guess it's quite an obvious answer for a foreigner from Eastern Europe, but I personally think my perspective represents the majority of my peers. Our dream was for Britain to be open, tolerant, forward-thinking.

I think it was a risky decision. I respect the determination behind the people who voted out of the EU, their determination for Britain to be 'Great' again, but I also think Britain is a great country and always will be. If we personify it, it's just like a human, always changing with time. Those who voted out seem to have trouble letting go of the old version of greatness: Britain as a strong-standing, independent, but closed-off island.

Leaving the EU will affect people within the Valleys and those who draw benefits from EU funding the most, both locals and newcomers, who will lose access to services that enable them to live in a multicultural society.

My hopes are that the young and British culture will be very resilient to the obstacles they're going to face, in order to remain open-minded and to continue to be citizens of the world and not just Britain. I hope for the young people that they will still want to travel and work abroad, to seek out different cultures and experiences, and not resort back to their own doorsteps.

I feel like Britain taught me that everything is possible. If I hadn't come here, I don't think I would have reached as far in life. I don't think I would have these big dreams. I don't think Poland would allow me to change my conditioning from a small-town mindset to a fulfilled go-getter who isn't scared of life. Britishness to me means tolerance. My biggest fear is that we will lose it. It won't get passed down through generations – and what sort of world will it be without tolerance?

PHOTOGRAPHER: REBECCA THOMAS

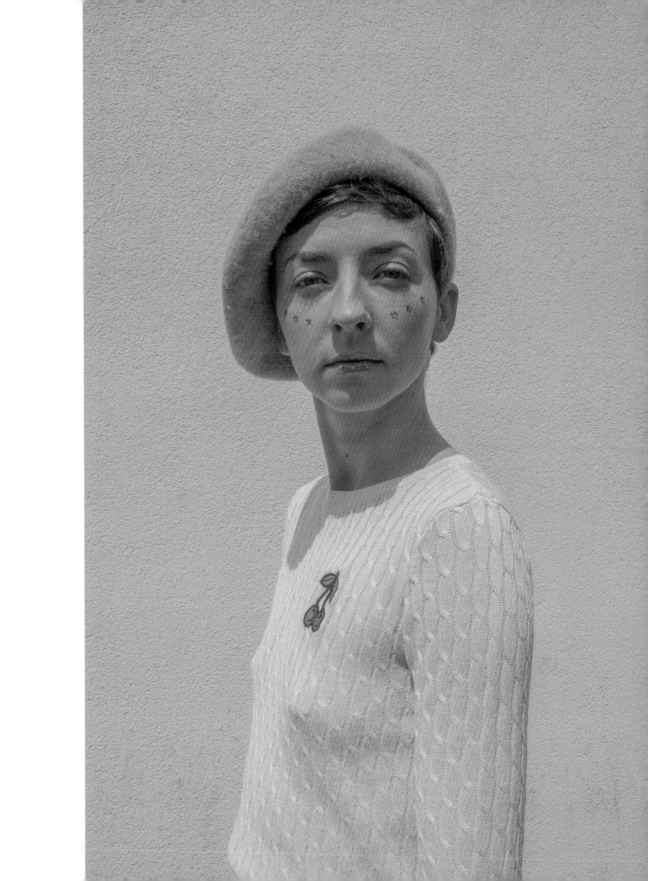

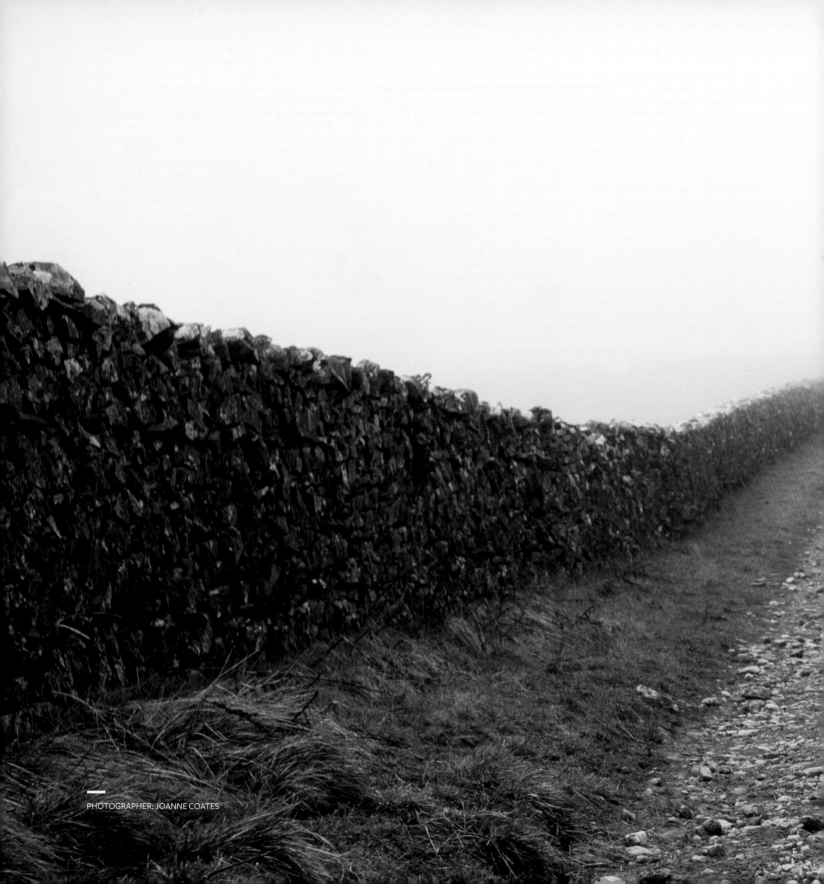

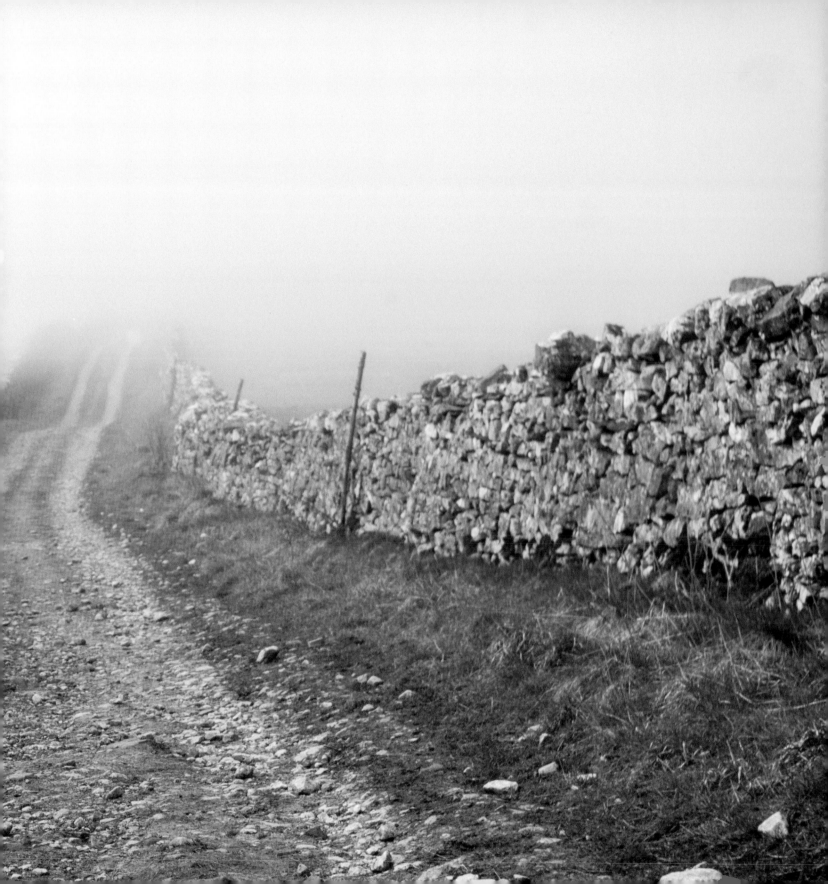

POLLY ALDERTON is a British artist currently using photography as her medium to explore the damage of neoliberalism on everyday lives and its toxic effect on society. She works on several long-term, self-motivated projects, often personal, using the premise of 'show, don't tell'. This is most prevalent in her striking portrait work.

POEM BAKER joined the Angela Woods Agency in 2016 and is a self-taught photographer, focusing on documentary, self-led projects, editorial and commercial work.

BOBBY BEASLEY is a social and documentary photographer based in Hull. He is drawn towards surreal and unusual situations, and his work aims to document life as he perceives it in the present moment, before it vanishes forever.

CARL BULL was born and raised on one of many council estates found in Derby in the East Midlands. He has a love/hate relationship with England and the people who live there, and believes good can be found within everyone.

ROBERT CLAYTON is a documentary photographer who photographs the British urban landscape. His first monograph, *Estate*, was published in 2015 to widespread acclaim. More recently he worked on the housing documentary film *Dispossession*. His work displays an intimate, sensitive and serious narrative on the condition of the British social landscape.

JOANNE COATES is an award-winning documentary photographer based in the north of England. She has contributed to the BBC, *Vice, The Telegraph,* and *The Guardian*. Her work has been exhibited both in the UK and internationally in venues including the Royal Albert Hall, Reveal-T Photography Festival, Cork Photo Festival and Somerset House.

INÈS ELSA DALAL is concerned with the authorship of archives in the interest of attaining representational justice. She responds to photographic commissions, produces exhibitions, and initiates projects. Currently based between Birmingham and London, she is interested in co-authoring portraits with people, by assessing the ethics of participation as part of the process.

LAURA DICKEN is a social documentary photographer and curator based in the UK. She is particularly interested in exploring identity, community and sense of place through her work. Her projects often celebrate individuals, groups and communities, both in Britain and further afield.

KAT DLUGOSZ is a Polish photographer and video maker based in Edinburgh, where she studied Photography at Edinburgh Napier University. She is interested in documentary portraiture and her work often explores issues related to the politics of representation, approached from an immigrant, as well as a feminist, point of view.

"This is Britain in the decade of cuts – but these aren't portraits of despair. They're stories of defiance, of fight and of faith that a better country awaits us all. These are your friends, neighbours, family – and they've got stuff to tell you."

ADITYA CHAKRABORTTY,
SENIOR ECONOMICS COMMENTATOR, *THE GUARDIAN*

AMARA ENO is a photographer, based between London and Cornwall. With a natural affinity for engaging with people, her practice predominantly leans towards social issues, where her primary aims are to initiate important dialogues between audiences and to empower those in society who are often misunderstood.

ALESSIA GAMMAROTA is an Italian photographer with a Fine Art degree from the Academy of Fine Arts in Florence and a Photography degree from the European Institute of Design in Rome. Her project, 'Brutal London', looks at the connections between different aspects of the housing crisis, from squatting and council estates to new developments changing the landscape and the city's soul.

DEBBIE HUMPHRY is a social photographer and researcher. She has published and exhibited her work extensively, including in the Royal Festival Hall and the National Portrait Gallery, London. She has worked with diverse marginalised groups for over 20 years, developing participative projects, and linking with campaign groups to fight for social justice.

ANDREW JACKSON is an award-winning recipient of the Autograph ABP 2018/Light Work International Photography Residency in New York, as well as being an Elliott Erwitt Fellowship nominee. He engages with the challenges of representation and narration within interventions that focus on the African diaspora, memory, family, storytelling and urbanism.

ANDREW JOHNSTON is a photographer from Belfast whose work documents the people and places within his home city. He is interested in sociology and how working-class people and communities live, and aims to capture and explore the present so that those in the future will be able to use his work to reflect on the past.

JENNY LEWIS grew up in Little Clacton, Essex before moving to Hackney, East London. As an editorial photographer, her work often captures vulnerable subjects and stories, and her first series, 'One Day Young', features pictures of women taken during the first 24 hours after giving birth. She has also published another series, 'Hackney Studios', which captures the extraordinary network of creatives who live alongside her in the borough.

GINA LUNDY is a British photographer based in Glasgow. Her recent work engages with women's economic activity and historic involvement in protest, specifically social housing, in London.

KIRSTY MACKAY is a British social documentary and portrait photographer. Her first book, *My Favourite Colour Was Yellow*, a project documenting the prevalence of the colour pink amongst young girls in the UK, was published in February 2017. Her work has appeared in publications including *Time, Le Monde, The Telegraph, The Observer* and *BJP*.

> *"Invisible Britain celebrates Britain in all its diversity, but also puts social justice to the forefront by directly confronting the cruelties of Austerity Rule and putting the forgotten people of Britain at its heart."*

COLIN PANTALL, WRITER, PHOTOGRAPHER AND EDUCATOR

JAMES MCCOURT is a photographer fascinated by his home. Since 2005, he has created a substantial archive of everyday life in west Belfast, working closely within different communities to capture often unheard stories.

JO METSON SCOTT is a photographer based in London whose work has been published in *The New York Times, The Telegraph, Le Monde* and *British Vogue*. In 2013 she published her first photography book, the Firecracker Award-winning *The Grey Line,* which focused on soldiers who had moral doubts about their involvement in the Iraq War.

MARGARET MITCHELL is an award-winning Scottish photographer working in documentary and portraiture. Her photographs portray individuals and their experiences of childhood, family, place and belonging. She has exhibited widely, and her work is held in the National Galleries of Scotland collection.

LES MONAGHAN is a photographer interested in class, community and representation. Previously a press photographer schooled in unambiguous imagery, he has deconstructed the documentary method through successive projects, staging photographs, working with texts, collaborating with others and recontextualising. His long-term projects often engage directly with the public.

J. A. MORTRAM is a social documentary photographer and writer based in Dereham, Norfolk. His ongoing project, 'Small Town Inertia', records the lives of a number of disadvantaged and marginalised people living near to his home, in order to tell stories he believes are under-reported. *Small Town Inertia* was published by Bluecoat Press in 2017.

NICOLA MUIRHEAD is a documentary photographer and visual storyteller, specialising in social long-form documentaries and portraiture. Her major projects focus on themes related to identity and place, and how they are impacted and shaped by political, environmental and socio-economic factors. She holds an MA in Documentary Photography and Photojournalism.

JOSEPH MURPHY is a documentary photographer currently based in Brighton. He manages his photographic work – both commercial and personal – around the workplace representative responsibilities he conducts for Unite the Union, and often incorporates this experience and knowledge into his image making.

KATE NOLAN is an Irish visual artist based in Dublin, focused on extended photographic stories that examine the nature of identity. Her work has been exhibited in solo and group shows in Ireland, Europe, Russia, USA and Nepal, and featured in a wide range of photography publications.

> *"What the eye does not see is what they don't want you to see, or think over, or act on. Stunning."*
>
> PROFESSOR DANNY DORLING, UNIVERSITY OF OXFORD

CIAN OBA-SMITH is an Irish Nigerian photographer from London. His work focuses on communities and subcultures around the world, with a particular interest in approaching subjects that are often misrepresented to present them in a different light. His photographs can be found in a variety of places online and in print including *FT Weekend Magazine*, *Dazed & Confused*, *The New Yorker* and others.

GRAEME OXBY is a photographer and lecturer. His work is largely concerned with documenting aspects of cultural life in working-class communities in the north of England, where he lives and works. His photo book about Elvis impersonators, *The Kings of England*, is published by Bluecoat Press.

LAURA PANNACK is driven by research-led, self-initiated projects that push her both as an artist and as an individual. Her art focuses on social documentary and portraiture, and seeks to explore the complex relationship between subject and photographer. She is drawn to adventure, and the desire to roam and play with the limitations and dynamics of photography as an art and as an act.

GORDON ROLAND PEDEN is a fine art photographer with an interest in history and politics. In 2015, after photographing the United Voices of the World trade union during its campaign at Sotheby's, he became a member and activist and has continued to photograph the union as part of a long-term project, which he hopes to exhibit in the future.

JON POUNTNEY has been taking photographs for over 25 years, since being given his grandfather's Voigtländer. He is passionate about working with communities and people to bring stories to life and out into the public realm. His recent work explores the industrial history of where he lives in South Wales.

LOUIS QUAIL has worked for some of the UK's best known magazines and has been published internationally. His latest project and book, *Big Brother*, won a Renaissance prize in 2017 and has received significant critical acclaim. Louis has twice been a finalist in the National Portrait Gallery portraiture award and his work is held in their permanent collection.

CINDY SASHA (CYNTHIA VARATHARAJA) is a British, Sri Lankan-born photographer and activist, who has worked in the creative industry for over 10 years and has an MA in Climate Change in order to understand the world's complexities. Her work revolves around playful Polaroids, documenting events and semi-biographical portraits.

DAVID SEVERN is a photographer whose work is concerned with the relationship between leisure, work and landscape. He is drawn to subjects that echo his encounters growing up in a former mining town, and seeks to capture a sense of place shaped by his memories and cultural background. His current project, 'Workers' Playtime', explores the history and significance of performance and entertainment within industrial communities.

> *"Let the ears of those responsible for austerity and its war on the poor ring with the words of these stories of defiant hope. Paul Sng's extraordinary book helps us see and hear the people who have lived through this devastating period in our history on their own terms."*

PROFESSOR LES BACK, GOLDSMITHS COLLEGE

JOHN SPINKS has been a freelance photographer since 1997. He works both commercially and on long-term projects. His second book, *The New Village*, was published by Bemojake in July 2017.

DUNCAN STAFFORD is a photographer from Sheffield whose speciality is music photography. He is also accomplished in street, portrait and documentary photography, and takes inspiration from the work of Marshall, Maier and Newton. His work has been published in *Rolling Stone*, and exhibited in the Louvre.

REBECCA THOMAS is a documentary photographer based in Wales who has a passion for using portraiture to explore people's stories. She studied at the University of South Wales, where she gained a first class honours in Photojournalism.

JON TONKS is a British photographer producing work that focuses on often remote and obscure stories about lives shaped by history and geography. He has been shortlisted for the Taylor Wessing Portrait Prize three times and presented with the Vic Odden Award 2014 by the Royal Photographic Society for his first book, *Empire*, which explores life on four remote British territories.

VIVEK VADOLIYA is a London-based photographer and director. Over the past two years he has produced projects focusing on Asian identity, youth and subcultures around the world, including an ongoing series titled 'The Thandi Express' about a bus service that transports many of the migrant communities around the UK.

TYLER WATT is a former creative director/producer who spent 20 years working across media platforms on blue-chip advertising/media campaigns. After the 2008 financial crash they decided to focus their lenses on documenting the asset-stripping of public land by local authorities, and the managed decline of the working-class neighbourhoods where they grew up.

DAN WOOD is a documentary photographer based in Wales. Predominantly self-taught, he came to photography through the skateboard subculture. His work primarily concentrates on people and place, and the projects he produces often echo subtle hints of personal history bound with a narrative and social commentary that he aspires to describe visually.

LISA WORMSLEY grew up on council estates in South London, and was given an old Soviet SLR when she was 14, saving money by processing film in her bedroom. She later became a professional documentary and music photographer, as well as a carer/support worker. She lives in Brighton.

FIONA YARON-FIELD is a photographer and psychotherapist who has participated in symposiums, publications and international exhibitions. She is one of the founders of the Uncertain States collective, and author of *Up Close*, a book that describes her relationship with her daughter Ophir, who has Down's Syndrome. Through subjects close and personal, she reflects on bigger social and cultural issues.

"*Invisible Britain is an anthology of portraits and testimonials from the grassroots, from the everyday man and woman who have been forced to ride the roller coaster of austerity. It captures the dignity and defiant spirit of resistance – the crescendoing voice of the invisible people who demand to be seen and heard.*"

ISHMAHIL BLAGROVE, WRITER AND FILMMAKER

"Here are the lives behind the stereotypes and the headlines. Here is the reality of lives lived large and small in marginalised communities all over the country. Lives that are invisible only to those in power, but to those of us who've tasted disability, poverty, unemployment, illness and criminalisation all too familiar. This is a beautiful collection – not bleak – a portrait of humour, resilience and endurance. It's brilliant."

KIT DE WAAL, WRITER

"This project is an important reflection of the reality of austerity measures in the UK. As a US resident, UK-born, it is beyond saddening for me to watch the security net not supporting the British, but tightening around people's necks; we have practically none in the US and I fear the direction in which the UK is heading."

JULIE GRAHAME, EDITOR AND PUBLISHER OF *ACURATOR MAGAZINE*

"These are moving and powerful portraits of people up and down the country whose lives have been blighted by social class inequalities. These are human voices bravely fighting for a more equal society."

PROFESSOR MIKE SAVAGE, LONDON SCHOOL OF ECONOMICS

"Photography enables a moment in the state of a nation to be captured and recorded with incisive focus. The portraits within this book offer a visual gateway to the stories of those unheard and invisible in Britain in this moment."

TRACY MARSHALL, DIRECTOR OF NORTHERN NARRATIVES

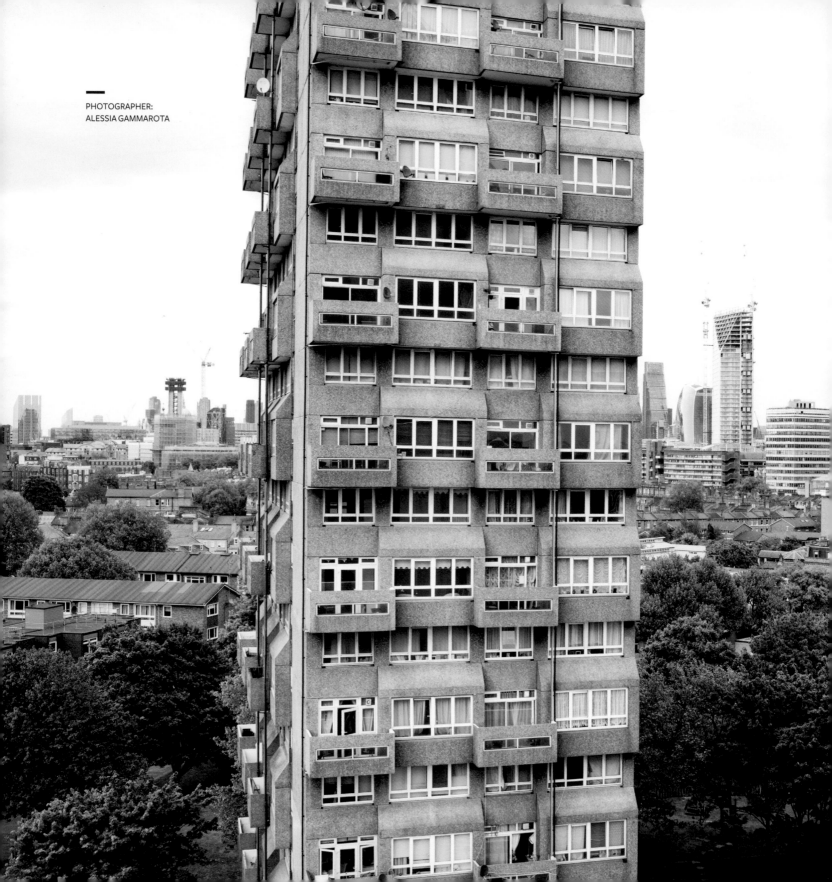

PHOTOGRAPHER:
ALESSIA GAMMAROTA

"*The images in Invisible Britain, together with each personal testimony, document the reality faced by many today, and give honest representations of the people involved and their communities. Through the validation of the different lives shown, vulnerable people living on the sidelines, alienated and neglected by our current government, will perhaps feel empowered to challenge harmful policies that disregard their wellbeing. They are no longer invisible. We can see their truth, and we do care.*"

ELLA MURTHA, THE TISH MURTHA ARCHIVE